IMAGES
of America

LOWER SAUCON
TOWNSHIP

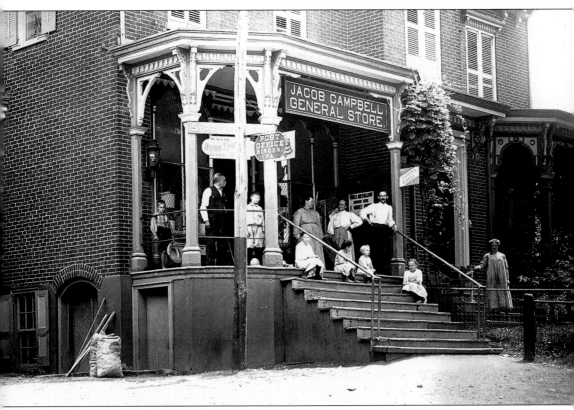

The Jacob Campbell General Store in Bingen was managed by a Civil War veteran who became disabled with a leg amputation at the Battle of Gettysburg. He is the gentleman on the porch to the left. The store had previously been operated by William Rohn Yeager (1822–1897), a Republican abolitionist who was the Bingen conductor of the Underground Railroad. Later, Preston Weiss and then Charles Weiss took possession of the popular general store, running it until the mid-1950s. The young lad to the left of Campbell is Russell Gruver. The two women are Mrs. Campbell (right) and her sister (left). Preston Weiss is on the right. Standing to the right of the steps is Preston's wife, Matilda. The girl on the third step is Amelia Mease.

IMAGES
of America

LOWER SAUCON
TOWNSHIP

Lee A. Weidner, Karen M. Samuels, Barbara J. Ryan,
and the Lower Saucon Township Historical Society

ARCADIA
PUBLISHING

Copyright © 2005 by Lee A. Weidner, Karen M. Samuels, Barbara J. Ryan, and the
 Lower Saucon Township Historical Society
ISBN 978-0-7385-3802-0

Published by Arcadia Publishing,
Charleston, South Carolina

Printed in the United States of America

Library of Congress Catalog Card Number: 2005921525

For all general information, contact Arcadia Publishing:
Telephone 843-853-2070
Fax 843-853-0044
E-mail sales@arcadiapublishing.com
For customer service and orders:
Toll-free 1-888-313-2665

Visit us on the Internet at www.arcadiapublishing.com

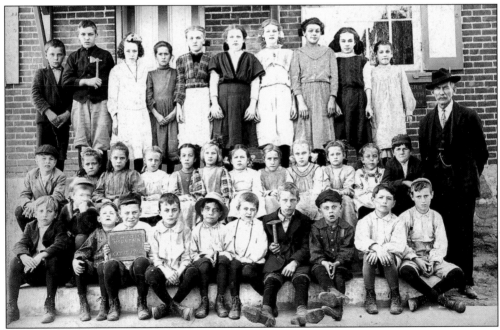

All township students attended grades one through eight in a one- or two-room schoolhouse
within walking distance of their homes. Here is the 1910 Lehigh Mountain School class, taught
by Reuben Weidner. The Steffen brothers stand out; in the front, Earl grasps a hammer, and in
the back, Archibald holds a hatchet.

CONTENTS

ACKNOWLEDGMENTS

We are grateful to the members of the Lower Saucon Township Historical Society, past and present, who gathered an amazing collection of photographs to help preserve the history of the township.

We would especially like to thank the following individuals and organizations for lending their photographs and assisting us with research: Gary Achey, Dale Berger, Bob and Mary Jane Bergey, Bill and Donna Bergstresser, Marcus Brandt, David Clauser, Priscilla deLeon, Ray Dimmick, Rev. Keith Easley, Frank Fabian, Peggy Fluck, Jack Gaither, Marjory Grimm, Ruth Gruver, Janet Gruver, Jeffrey Hahn, Handy Dan, Linda Heindel, Jody Hijazi, Ron Hineline, Alfred and Mary Ann Horvath, Sharon Jezick, Richard Kantor, Glenn Kern, Pastor David Kochsmeier, Ken LeVan, Tom and Keri Maxfield, Tomi McIntosh, Tom McLaughlin, Pastor Tricia McMackin, George and Kathleen Morgan, Richard Mullins, Sally Murphy, Bernie Ortwein, John and Carol Ortwein, Ken Raniere, John C. Ravier, Robert Ravier, Laura Ray, Darlene Repash, Len and Nancy Roberts, Stephen and Fran Roseman, William Rowe Jr., Dorothy Pichel Schneider, Louis and Dorothy Seeds, Bill Shimer, Joe Sofka, James Sturm, Kristina Taylor, Clay and Sue Waltermire, Bob and Emily Walters, Beatrice Weidner, John W. Weiss, William Weiss, DonRoy and Kim Wirth, Stanley and Gladys Wohlbach, Sandra Yerger, Hellertown Historical Society, Northampton County Historical and Genealogical Society, Saucon Valley Conservancy, Church of the Assumption Blessed Virgin Mary, Christ Lutheran Church Lower Saucon, Ebenezer New Reformed Church, New Jerusalem Evangelical Lutheran Church, and Steel City Mennonite Church.

We would also like to thank our families for their love and patience during this project: Elise and Michael Ryan; John, Teddy, and Tommy Samuels; and Lynn, Bobby, and Laura Weidner.

INTRODUCTION

Until the mid-17th century, the Lenni Lenape (Delaware) tribes hunted and inhabited the land of Lower Saucon Township. European traders first appeared in the area prior to 1700, and the Native Americans peacefully traded with these outsiders, although some minor skirmishes did occur. William Penn was granted land on March 4, 1681, by King Charles II to repay a debt owed to Penn's father. The land grant included what is now Lower Saucon Township. However, Penn soon realized that he needed to purchase the land from the Native Americans to maintain clear ownership. Penn advertised throughout Europe, offering 100-acre parcels of land for 40 shillings, subject to a rent of one shilling per annum forever.

In 1737, Penn's sons expanded their land holdings to include most of the Lehigh Valley through the "Walking Purchase." Although the Lenni Lenape did not think this was a legitimate claim, they eventually moved out of the area, allowing Europeans to settle it. Sometime before 1737, Nathaniel Irish established a farm, built a grist- and sawmill, and opened a land office for William Penn. He is considered the first European settler in Lower Saucon Township. His land later became known as Shimersville. Irish was the first justice of the peace in the area, and the first "King's Highway," from Philadelphia to the Lehigh Valley, built in 1737, led to his property.

Lower Saucon Township was chartered in 1743, when it was still a part of Bucks County. It was established in the rich farmland along the Saucon Creek. The name is of Native American origin, from *sakunk*, meaning "at the mouth of the creek." The township also included South Bethlehem until 1865 and Hellertown until 1872. German immigrants, convinced by Penn's favorable description of the New World, settled Lower Saucon Township in large numbers, beginning in the 1730s. Some of the surnames of the early German settlers were Boehm, Wagner, Appel, Riegel, Lerch, Laubach, Oberley, Heller, Shimer, and Lutz. These early settlers were hardworking, and their farms prospered. There were numerous mills built to provide sawed wood, flour, textiles, paper, and gunpowder. Other early industry included lime kilns and the extracting of zinc and iron ore.

During the Revolutionary War, many German farmers enlisted in the Continental army to fight the British. At a time when the army's reserves were depleted, they offered to sell wheat and rye on credit. In 1777, soldiers of the Continental army transporting the Liberty Bell to Allentown passed through Lower Saucon, spending a night in Leithsville. The Marquis de Lafayette, according to legend, stopped at Wagner's Tavern in Hellertown on his way to Bethlehem during the war.

The first church, Lower Saucon Church, was established in 1734, soon after the early settlers had arrived. It was built by a German Reformed congregation on what is now Easton Road. There were 10 schools in place in the township even before the legislature of Pennsylvania adopted the public school system in 1834. These schools were established by the local church congregations.

When the North Penn Railroad, connecting Philadelphia to Bethlehem, was completed in 1856, this 55-mile line provided an impetus to building iron smelters in Bingen, Hellertown, and Iron Hill, due to the township's wealth of iron ore and limestone. The railroad brought coal to this industry, transported pig iron to markets, and provided transportation for the township's population. Lower Saucon Township felt the influence of the Bethlehem Steel Company. The executives purchased farmland in the township to build large estates, and the steel company became the largest employer in the area. When it ceased manufacturing in 1995, many residents of Lower Saucon suffered loss of employment.

Today, farmland continues to be lost to housing development at a startling rate. The township still possesses beautiful woods, streams, and rolling hills, but care must be taken to preserve these open spaces that remain.

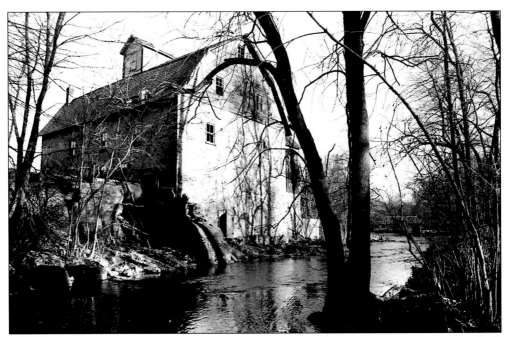

Ehrhart's Mill stood along the Saucon Creek in historic grandeur until the 1995 fire, which destroyed this important remnant of an earlier era.

One

COMMUNITY

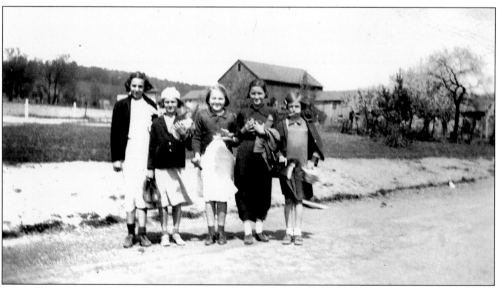

These five girls are likely on their way to school *c.* 1929. From left to right are Ruth Quier, Kathleen Adams, Ethel Kousz, Elizabeth Danzer, and an unidentified girl. Lower Saucon Township students had to walk long distances on country roads to attend. Notice how nicely they are dressed. It was the expectation, at that time, that students arrive at school looking well groomed.

John Wolst married Elizabeth Evert on August 30, 1914, and started a large farm in Leithsville. He sold a portion of the land to John R. Bechtold, who then created Bechtold's Orchard there.

Bernie Ortwein's grandmother emigrated from Hungary in 1824 and then lived on the Ortwein farm in Seidersville.

John Wolst and his sister Catherine pick strawberries at the Wolst farm, located along Rural Route 1 in Leithsville, in June 1970. Catherine married Raymond Ortwein of Seidersville in 1943. The couple lived on a section of the farm until selling it in 2002.

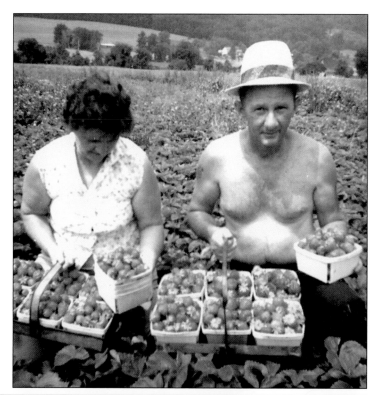

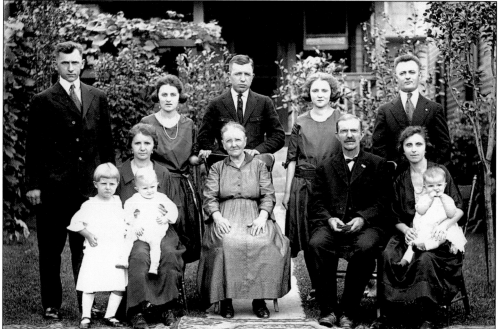

The Evert family members in this 1921 photograph include, from left to right, the following: (first row) Catherine Wolst, Elizabeth Evert Wolst (holding John Wolst), Elizabeth (Mrs. Lawrence) Evert, Lawrence Evert, and Agnes Gimpert (holding Kovacs Gimpert); (second row) John Wolst, Margaret Evert, Anthony Evert, Theresa Evert, and Joseph Gimpert.

Gladys Hafner Wohlbach poses in front of her University Heights home in 1938. Joe and Elizabeth Hafner are behind her.

Wilbur Hafner explores the ruins of Professor Larkin's home in Billiardsville, now known as University Heights. It was named Billiardsville after the Van Billiard family, who immigrated to Lower Saucon and built one of the first log homes in the 1700s.

Thomas J. Van Billiard was born in 1857 in Lower Saucon, Northampton, Pennsylvania, to Samuel and Juliana (Kidd) Van Billiard, who resided on Philadelphia Road. Thomas lived in the township until 1880, when at the age of 23 he migrated to Iowa. He was the grandson of Jacob Van Billiard, a well-known patriarch, and the great-grandson of Henry Van Billiard (known to the elders of the family as Verbilger), reportedly one of the first settlers on Lehigh Mountain.

Billiardsville, more commonly known today as University Heights, was founded by Henry Van Billiard, who immigrated to this country in the 1700s. Family records state that Henry built a log cabin on South Mountain. Pictured in this family photograph are his descendants. From left to right are the following: (first row) Carrie Dimmich Van Billiard, Catherine Schick Van Billiard, and Russell Van Billiard; (second row) Howard, Harry, and Reese Van Billiard.

George Mar (far left) and his son Steve appear with an unidentified young lady and Bruno Kazaro (far right) in 1948 at the Mar farm on Reservoir Road. The property, once an orchard, is now occupied by the Silver Creek Country Club.

Edith Reiss holds her son Stewart at the Herman homestead along Polk Valley Road.

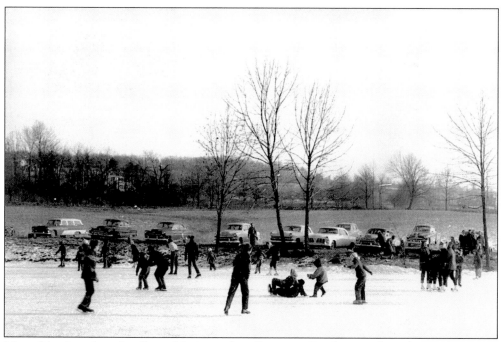

Many friends gathered at Steve Mar's pond on Reservoir Road to ice-skate during the winter months in the 1940s and 1950s. This photograph was taken in 1955.

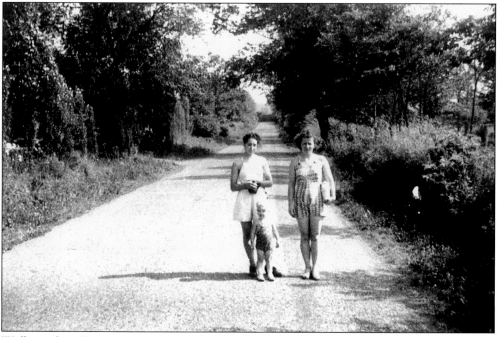

Walking along Reservoir Road in 1940, Betty (Szalay) Pagets (left) and Yolan (Mar) Roseman return home after picking wild raspberries. Little William Pagets tags along.

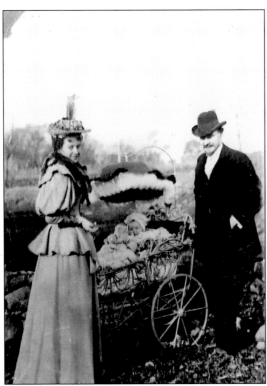

Elsie and Robert Christenson stand with their daughter Olga outside their Polk Valley farm in late 19th century. The photograph was created from a tintype.

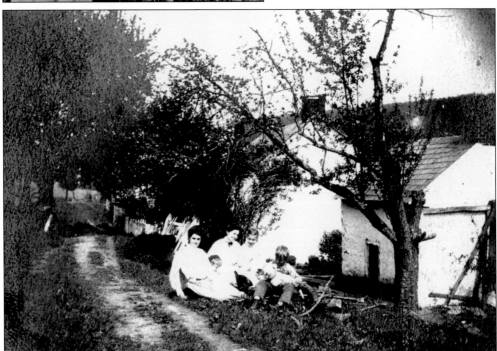

Robert August Christenson's first farmhouse was located in Polk Valley, just before the Polk Valley School. In the center of this photograph is Elsie (Haas) Christenson. Elsie's sister Bertha is the other adult. Elsie's children are, from left to right, Olga, Rolf, and Paul.

Paul Christenson spent many evenings playing his accordion for the family. Grace Achey of Hellertown recalls his dozens of sheet music. Paul later became leader of Boy Scout Troop 19 with David Weidner, his assistant.

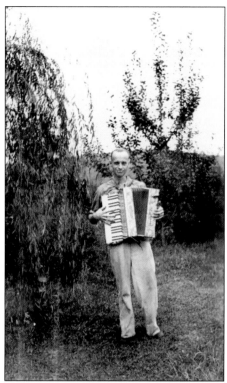

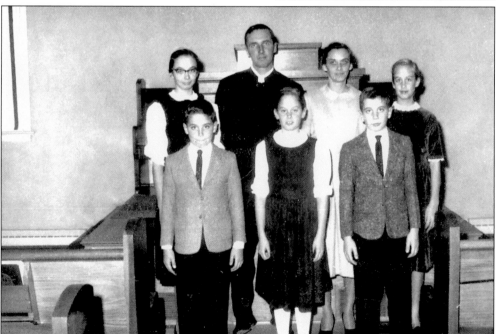

The Walters family of Steel City poses for a portrait c. 1975. From left to right are the following: (first row) Tim, Becky, and Mark; (second row) Dawn, Bob, Emily, and Susie. Bob Walters was the pastor at Steel City Mennonite Church from c. 1962 to 1982. Tim and his wife, Lisa, own a landscaping business and beautify many homes and businesses in Lower Saucon Township.

Theresa Doncsecz pumps water from her well outside her home on Lower Saucon Road, near Polk Valley Road. The homestead was rebuilt in 1933 and still stands today.

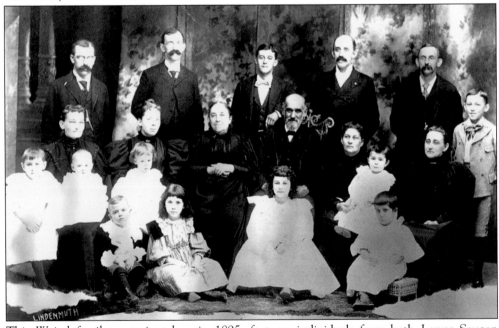

This Weisel family portrait, taken in 1895, features individuals from both Lower Saucon Township and Hellertown. From left to right are the following: (first row) James H., Mary (Ainsley), Nettie, and Susan; (second row) Annie (Weisel) Rickert, Emma (Knecht), Robert E., Annie (Heiser), Charles, Sybilla (Laubach), Henry, Hannah (Landis), Joseph, Laura (Riegel), and Harvey; (third row) Edward, James, Ray, William, and George.

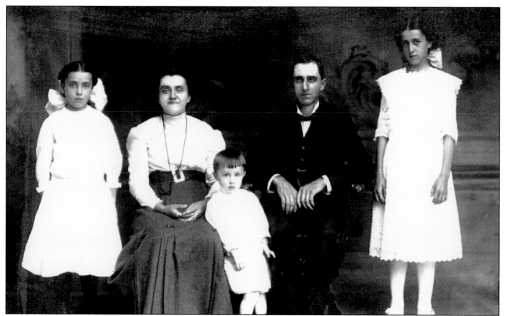

This *c.* 1913 portrait shows second- and third-generation Seiferts who lived at the farm located at Polk Valley and Lower Saucon Roads. First owned by carpenter Aaron Seifert, the farm is now co-owned by Laura Ray and fourth-generation family member David Seifert. Pictured here are, from left to right, Sadie, Emma, Elmer, Robert, and Miriam.

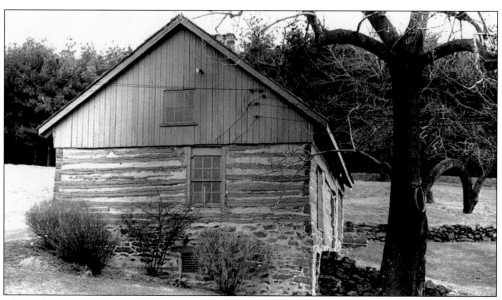

This cabin, located near Polk Valley Road, was erected in 1789, built with rough-hewn logs sealed with lime and sand grout and hand-cut shingles. The interior consisted of two rooms of plastered walls. In one room was a large open hearth serving as the heating system and cooking facility. The two upstairs rooms were accessed by a ladder. The log cabin was built on a William Penn land grant by William Gruber and Leonard Syphert. Its location was determined by its proximity to water; near the cabin's front is a spring (now called the Getter Spring after a former owner), which produces pure water.

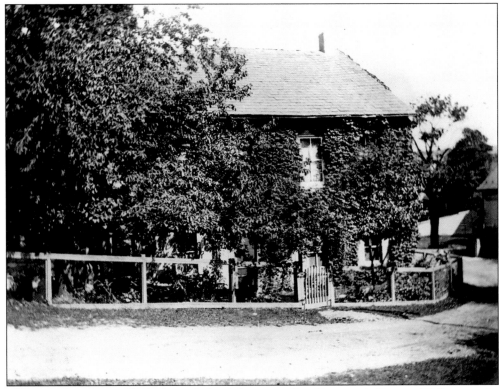

This camera angle reveals the house behind the gristmill at Kunsman's Corner. Walking to the left on the road would have taken a pedestrian to the millrace.

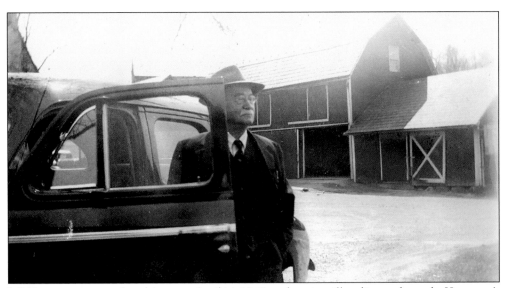

J. P. Kunsman emerges from his car on April 14, 1946, at the gristmill and general store by Kunsman's Corner. John P. owned the store, and his son John Jr. worked the mill. His children Grace, Mary, and Kenneth taught at the public schools. He and his wife, Laura, had eight children.

This is a beautiful Felker Studio photograph of Martha Hahn, who lived in Lower Saucon Township prior to 1920.

Elmer Shimer holds his son William. When this photograph was taken on the Herman farm, along Polk Valley Road, c. 1919, William was the eldest child. Elmer and his wife, Annie Herman, also had two more children: Edith and Henry. As a young man, William worked at Fritchman's Luncheonette in Hellertown, served in World War II, and then worked until retirement at Bethlehem Steel. He died in February 2005. William's favorite quotation began, "If I had a nickel for every hundred pounds of potatoes I picked. . . ."

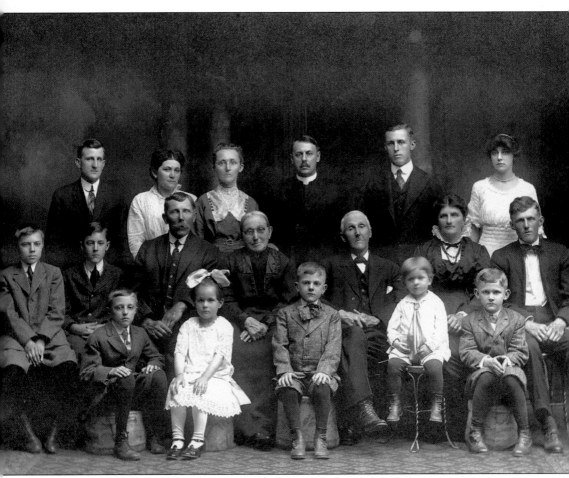

The ancestors of Jeffrey Hahn are seen in this early-1900s photograph. From left to right are the following: (first row) Robert Laury, Mildred Shimer Hahn, Sterling Weber Shimer, Ray M. Shimer, and Walter Weber; (second row) Winfred Laury, Joseph Ellis Laury, Howard Weber, Catherine Beidelman Weber, Joseph Weber, Amanda Durns Weber, and Truman Weber; (third row) John Shimer, Stella Weber Shimer, Carrie Weber Laury, Rev. Preston Laury, Harold Laury, and Elizabeth Laury Billings.

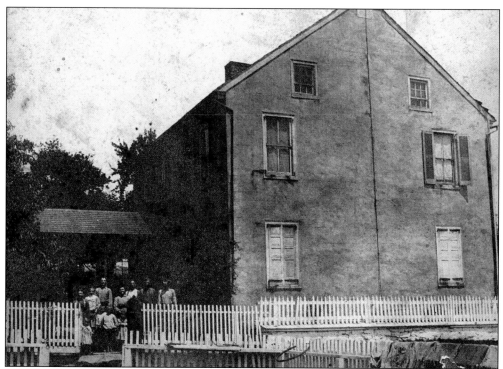

The Martin Shimer homestead was also the former residence of Mildred (Shimer) Hahn's grandfather. It was located on the old Leiberman farm, near the Lutz Franklin Schoolhouse. The Salvatore Narzisi family owned the farm. When Salvatore died, it was turned into the Sandy Lakes Golf Course, now known as Woodland Hills Country Club.

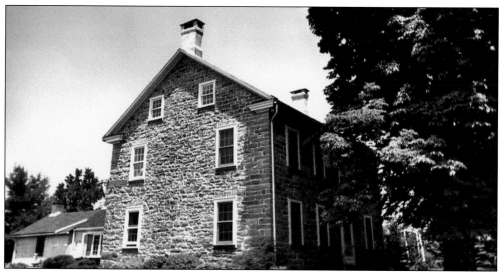

The original Shimer farm was purchased by B. Franklin Shimer in 1740. In 1775, Edward Shimer built the house pictured here. About 100 yards from this stone home rests the wall-enclosed private plot where Edward and Rosina (Seip) Shimer are buried under marble slabs with German inscriptions. The ruins of the 1740 home stand in a wooded area on the property. The acreage is just off Lower Saucon Road, behind the Helms farm.

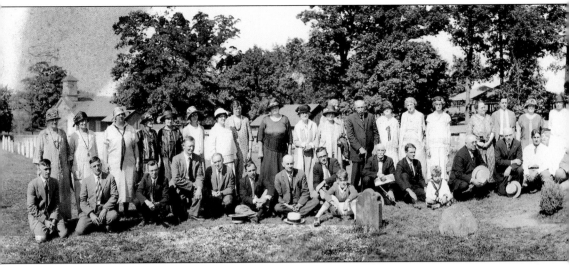

Shortly after 1725, Jacob Sheimer and Mathias Riegle established a settlement at the mouth of Saucon Creek in what was to become Shimersville. In 1801, Jacob Shimer, a descendent of Jacob Sheimer, erected a stone house near the creek. In 1812, he purchased the nearby gristmill from Nathaniel Irish. It was enlarged in 1829 and leased to William Chamberlain. Due to

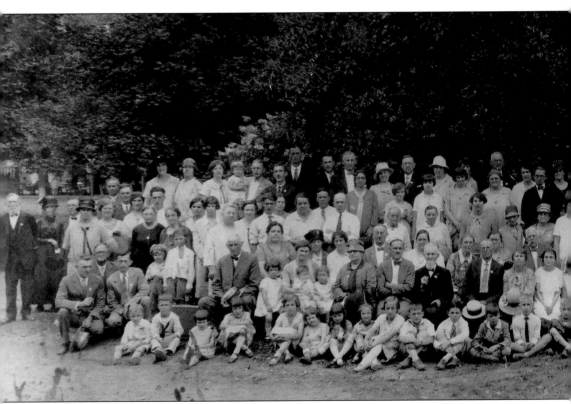

In 1738, Johann Reinhart Laubach arrived in Philadelphia with his son Johann Christian and made his homestead in Lower Saucon along what is now known as Laubach's Creek. The family grew to many thousands of descendants across the United States. Reunions began in the early

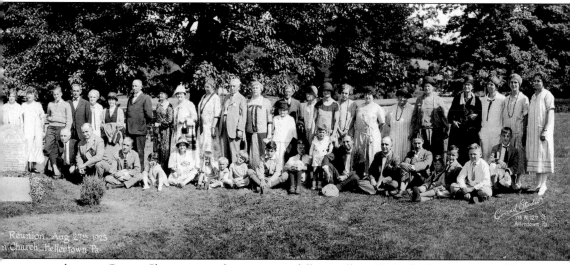

water damage, George Shimer erected a new stone fulling mill in 1844, which was inherited by William Shimer. The growth of Shimersville was fueled by various industrial and transportation developments in the mid-19th century through early 20th century. The Shimer family reunion pictured here was held on August 27, 1925.

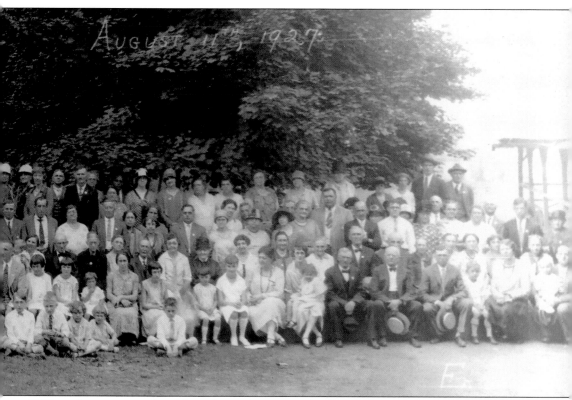

1900s and continue today. Many descendants may also be related to other Saucon families, as the Laubachs married into the Lutz, Linn, Hauck, Weitknecht, Lerch, Bahl, and Freeman families. Pictured here is the Laubach family reunion of August 11, 1927.

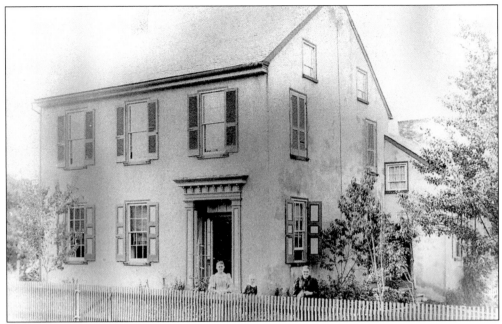

Susanna Harris (right), the wife of Theodore Freeman Laubach, and her daughter Cora (Laubach) Illick stand in front of the 1762 Laubach homestead in 1893. The child is unidentified. A side porch has since been added to the home and the shutters removed. Easton Road cuts through the property today. The house is easily recognized as one built by Germans, as it has just one chimney in the center for the stove. If the house included chimneys on each end, it was built by the Scottish, Irish, or English, who traditionally used fireplaces.

Christian Laubach was one of the first settlers of Lower Saucon Township, making his home in the east, on what is now Easton Road. In this photograph, four generations of the Laubach family pose together. From left to right are Hiram (1865–1938), George (1835–1925), Rev. George Jacob (1892–1959), and Dr. George Brutzman (1918–1997).

Sybilla (Laubach) Weisel (right) of Lower Saucon Township distributed a friendship book (below) to relatives and acquaintances in 1851. They signed tributes, composed poems, and related favorite scriptures in a private collection of verse and prose. This script was written by M. Shimer of Lower Saucon Township the year before Sybilla's marriage to Henry Weisel of Hellertown. The keeping of this type of ledger was traditional during the 19th century.

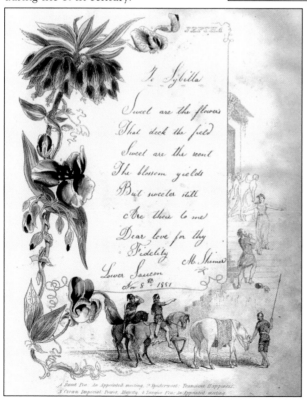

To Sybilla

Sweet are the flowers
That deck the field
Sweet are the scent
The blossom yields
But sweeter still
Are there to me
Dear love for thy
Fidelity M. Shimer

Lower Saucon
Nov 8th 1851

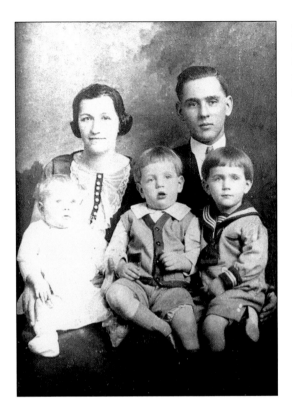

Ella and George Ringhoffer had six children, though only the three oldest were born when this 1924 family portrait was taken. From left to right are Margaret, John, and George.

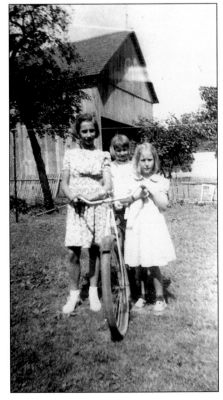

En route to the one-room schoolhouse, Ella Mary (left), Geraldine Ann (center), and Rose Marie Ringhoffer (right) preferred riding bikes to walking. Geraldine and Rosie loved horses, while Ella was a hardworking farm girl and loved the cows and chickens.

Mary Catherine (Isler) Kies and her son-in-law Robert Weisel are shown here in a music spoof. Mary plays a tune on a watering can, and Robert strums a broom in pre-1920 Saucon Cross Roads in Lower Saucon Township.

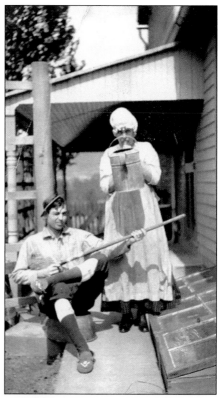

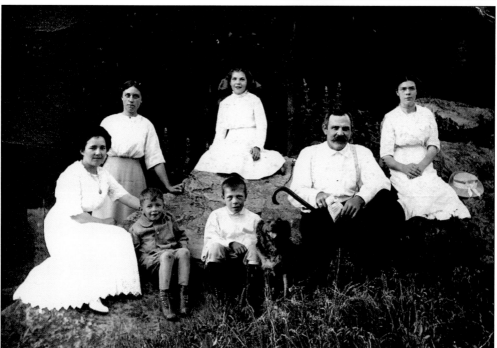

Pictured near the Saucon Creek are, from left to right, Laura Smith, Jennie Folk, Willis Snyder, Lewis Kies, Bertha Kies, Frank Kies, and Elizabeth Kies.

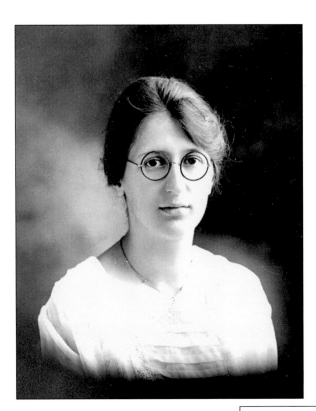

Leona (Metzger) Weisel taught school in Lower Saucon Township and Hellertown after graduating from Kutztown Normal School during the early 1900s.

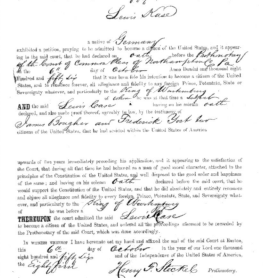

This rare document officially declares the immigration of Lewis Kase, a native of Germany, on October 6, 1856. It is signed by the prothonotary of Northampton County, Henry F. Steckel. Later, Kase would change his surname to Kies as a resident of Lower Saucon Township.

Herbert Weisel of Hellertown helped found the original Lower Saucon Township Historical Society in 1965. Their main projects to preserve the history of the township included publication of the *Lookback*, the periodical of the society, and the preservation of the Lutz Franklin School, a one-room schoolhouse museum.

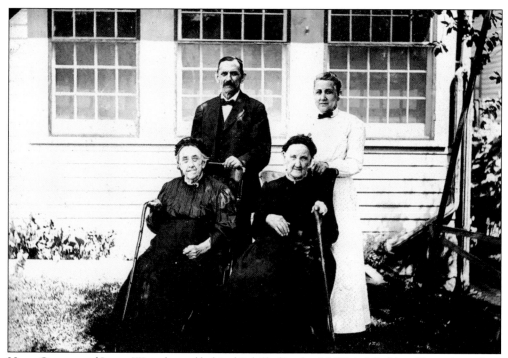

Here, George and Laura Weisel stand behind Sybilla (Laubach) Weisel (left) and Laura's mother, Grace Riegel. Many families from Lower Saucon Township and Hellertown intermarried, thereby creating two tightly related bordering communities.

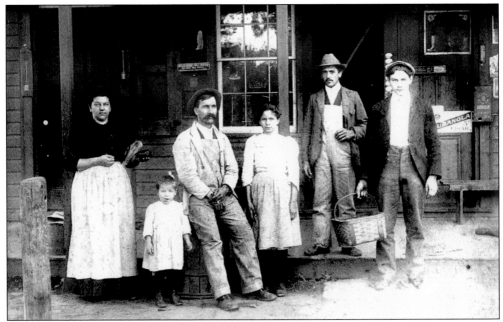

This c. 1900 photograph shows, from left to right, Anna and Jacob Wasser (with their two daughters), Jacob's brother John, and John's son. The Wassers were the first owners of the Wassergass general store. Jacob sold the store to A. L. Bergstresser in 1903.

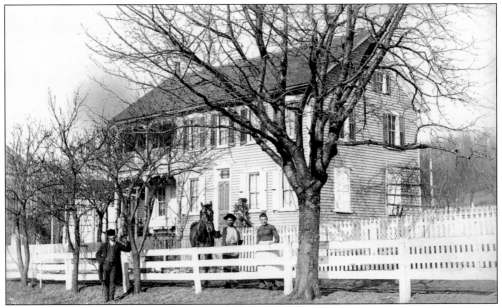

Northampton County records show that the first sale of this Wassergrass Road house, with nine acres, occurred in 1833 from a John and Elizabeth Leidy (or Leidz) to Jonathan Biery. Unfortunately, there is no record of the house's construction date, but it may have been built as early as 1797. The property then exchanged hands 11 more times up to the present. It was one of the first and largest wood-frame houses in the area. The property has served as a crop farm, lumbermill, and small dairy farm. It is now solely the residence of the Roberts family.

Taken in 1915, this photograph depicts part of the farmland of James Monroe Weiss near Leithsville. Quite a few children are hidden in the tree, a great climbing tree if given a ladder or a boost.

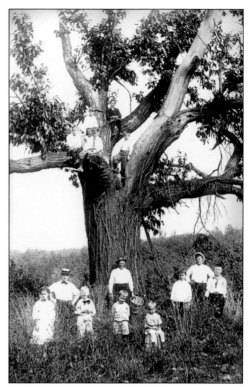

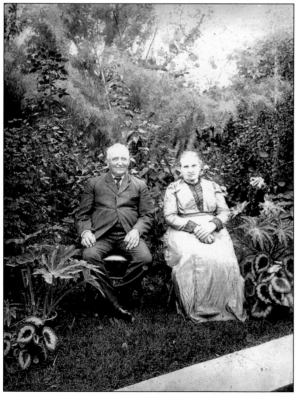

Surrounded by a magnificent garden are Grandma and Pa Weiss, also known as Jim and Sarah. They owned a farm and orchards off Flint Hill Road in Lower Saucon, near Leithsville.

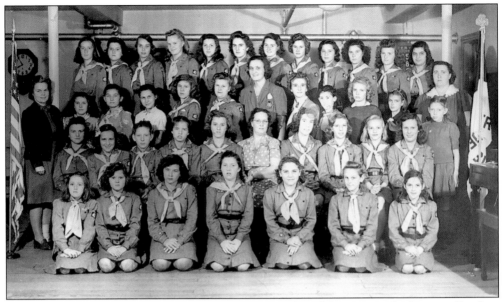

Girl Scout leader Evelyn Wallace (far left) proudly stands with her troop, which met at Friedens Lutheran Church in 1946. From left to right are the following: (first row) two unidentified girls, Jane Kutz, Genieva Ubberoth, Betty Lou Miller, unidentified, and ? Musselman; (second row) unidentified, Lucille Beck, unidentified, Mary Nelmes, unidentified, Mrs. Reinhart, Phoebe Lythol, Rosalie ?, Louise Schuster, and Irene Hari; (third row) two unidentified girls, Beatrice Rowe, Joyce Barthold, Joyce Cope, Mrs. Sloyer, Dorothy Riondet, Janice ?, Patricia Leun, and two unidentified girls; (fourth row) unidentified, Joyce Koehler, Kathryn Mindler, Connie Koshko, Camella Carvis, Marie Butz, Joyce Kline, June Kuhns, Kitty Miller, Laverne Kutz, unidentified, and Rosemary Pum.

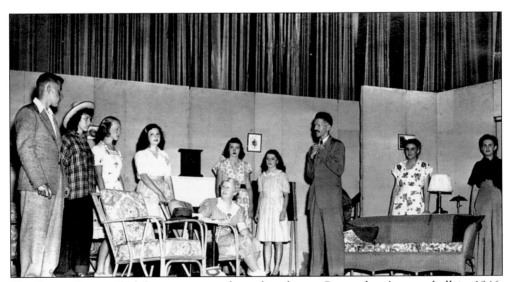

The Lower Saucon Girl Scout troop performed a play at Coopersburg's town hall in 1946. Pictured here are, from left to right, Dean Kemmerer, Joyce Barthold, Louise Schuster, Carmella Carvis, Joyce Cope, Kitty Mindler, Lucille Dougherty, Ray Ball, Janice Williams, and Marie Butz.

Ruth Gruver, daughter of the Gruver Hotel owners, was the pitcher for Lower Saucon's Bingenettes, a female baseball team that enjoyed eight seasons during the 1930s. The team played other hardball teams such as Richlandtown, Steel City, Allentown, and Center Valley. This photograph was taken before a game against Petersville. Ruth had such a great pitching arm that the All American Girls Professional Baseball League sent a recruiter to sign her for their team. Ruth's father was opposed to her joining the league, so she continued to play on local teams.

Bingen Field was a popular area for youth and adults to congregate during the 1920s and 1930s. The Bingenettes, a women's club, played hardball here against young men's baseball teams. A parking lot adjacent to the playing field became known as the "Bingen Naval Academy" among young men in Hellertown. They would take their dates here for stargazing and spooning. This photograph shows, from left to right, the following: (first row) Geraldine Mindler, Doris Hallowell, Gloria Yob, and Jean Eisenhart; (second row) Verna Mindler, Bobby Hallowell, Charlie Weiss, Raymond Kelchner, and Bobby Hein.

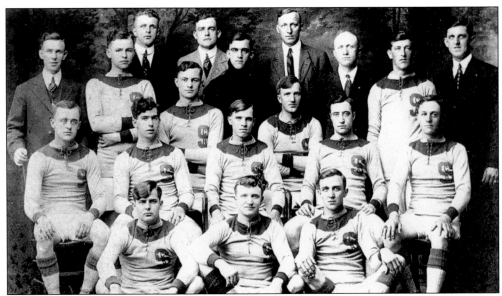

In 1916, the Saucon Crossroads Athletic Club was located at Hellertown Road and High Street, next to the Cross Roads Store, since this area had not yet been added to the borough limits and was part of Lower Saucon. The above players won second place in the Blue Mountain League. From left to right are the following: (first row) ? Antler, John Galbraith, and Austin Kies; (second row) Miles Apple, James Strawn, William Gozzard, John Bennet, and Norman Apple; (third row) Edward Bachman and S. Peffer; (fourth row), E. Peacock, George Diehl, Edward Shilling, Morris Dimmick, Joseph Hahn, John Piffer, Herbert Hoffert, Jack Lawler, and Howard Eckert.

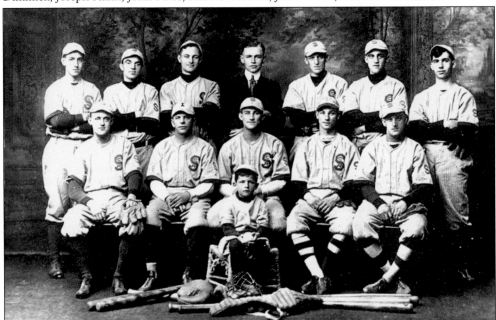

In this photograph of the Saucon Crossroads Athletic Club, Kenneth Dimmick is the bat boy. The others are, from left to right, as follows: (first row) Miles Apple, unidentified, Ted Hagey, Hap Bills, and Poppy Hahn; (second row) Bert Strawn, Bill Diehl, Ed Bachman, George Diehl, Doc Eckert, Joe Hahn, and Bill Strawn.

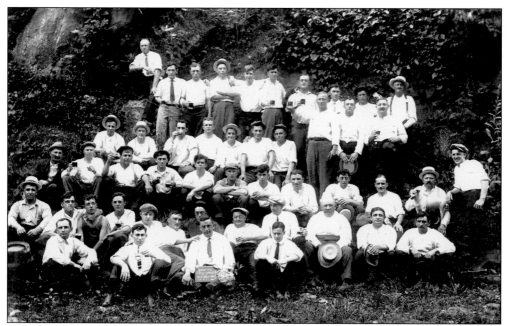

These men compose the Saucon Cross Roads Fire Company, a fraternal club enjoying its first annual outing in 1915, when the Cross Roads area north of Hellertown was still Lower Saucon Township. In the second row, the eighth young man from the left is Herb Cless, later an important figure in Hellertown. It appears that a clambake might be in store for the club.

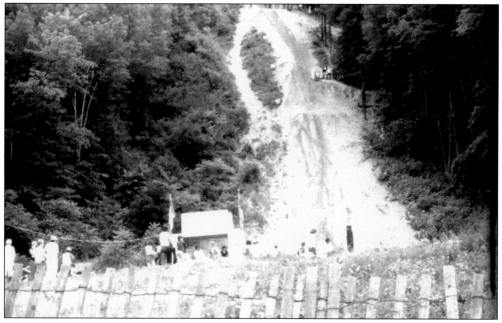

Twice a year, motorcyclists from all over the country compete in Steel City's Bushkill Valley Motorcycle Club Hill Climb. Each rider has two attempts to get his custom-fitted bike up the 80-degree incline and over 650 feet of silicon soil. The climb began in 1922, when the area was owned by the Bethlehem Motorcycle Club. The Bushkill Valley Motorcycle Club purchased the site in 1956.

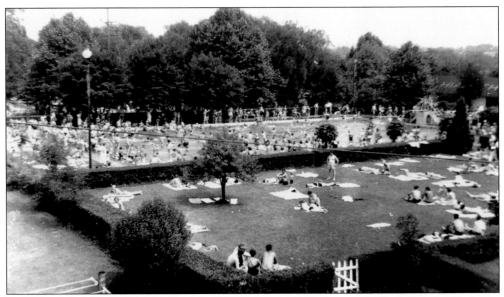

Bob and Vivian Fitzsimons bought Hiawatha Swimming Pool from Frank and Jenny Kardos in 1947. Bob had lifeguarded for the original owners during summers while attending college. The pool had to be emptied every three weeks due to the lack of a filtration system. On Sundays in August, Hiawatha was filled to capacity, but business began to slacken on account of the polio scare. In 1960, competition and increased maintenance costs forced the Fitzsimons family to close the pool and sell to Bethlehem Steel. It was razed in 1961.

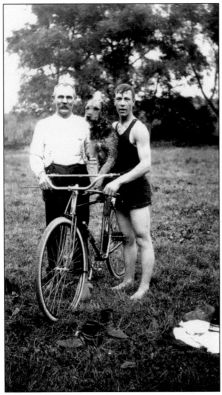

Frank "Pappy" Kies and his son Lewis support their pet Sandy while riding a bicycle near the Saucon Creek in Lower Saucon Township in 1918. Lewis is wearing a typical swimsuit of the time, made of wool. It was frowned upon for men to go topless.

These bathers return to their cars after taking a dip at the swimming hole at the Pichel farm.

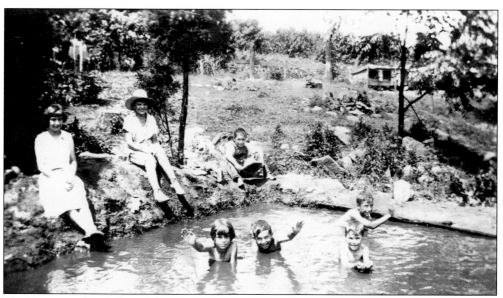

The Dorsey and Mabel Wohlbach farm on Wassergass Road included a homemade mud-walled swimming hole where children splashed on hot summer days. The pool washed out during heavy rains and had to be dug out again. The cows also waded in the water on the way back from the fields. This meant that the unfiltered pool sometimes contained *mischt brieh*, but the swimmers did not mind. Shown here in 1931 are, from left to right, the following: (on the bank) Anna, Grace, and Lester Wohlbach; (in the pond) Helen Wohlbach, Rollin Kichline, Leon, and Stanley Wohlbach.

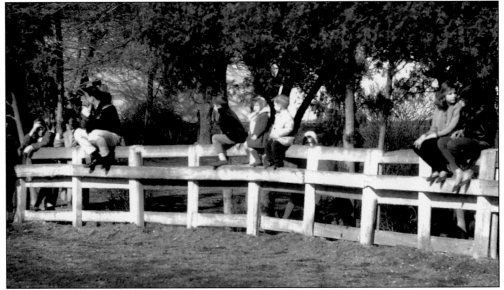

The Patterson Stables, located on Bingen Road across from the Hiawatha Pool, was a popular spot for equestrian activities. This photograph was taken c. 1966.

Washington's Monument in Cherry Blossom Time

C. H. WEISS' STORE

General Merchandise

Phone Hellertown 2483

P. O. Bethlehem, R. D. 4 Bingen, Pa.

NEWTON MFG. CO., NEWTON, IOWA

The C. H. Weiss store was first established by William Yeager, who passed ownership to Joseph Campbell. Preston Weiss was a relative of Campbell and continued the operation of the store, passing it on to his son Charles Weiss. In 1962, the Pennsylvania Department of Transportation rerouted Bingen Road, which had previously run in front of the store. Charles Weiss was so disgusted with the change in the road that he walked out of the store (leaving all the merchandise) and never returned. Seen here is a calendar printed for customers.

Frankie Doncsecz, an army soldier in the 82nd Infantry, poses beside a DeSoto roadster. On the left stands Mike "Nick" Doncsecz of the Medical Corps.

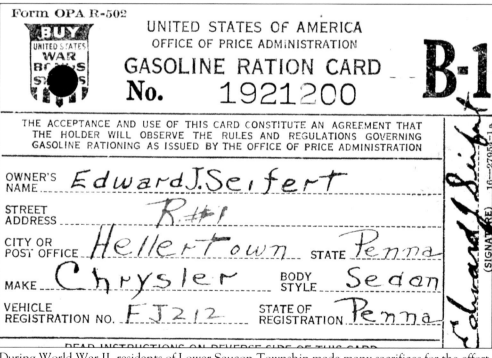

During World War II, residents of Lower Saucon Township made many sacrifices for the effort. This gasoline ration card was implemented by the government to conserve natural resources. Edward J. Seifert was one of the many township residents who assisted the armed services by carefully monitoring the consumption of gasoline.

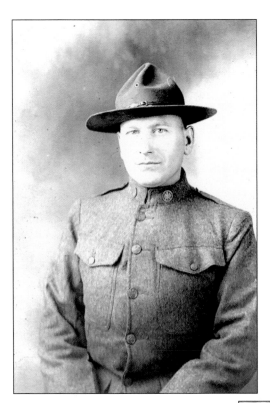

Frank Weidner went to France during World War I to serve as an aircraft repairman. He lived in Lower Saucon Township in 1917 at the time of his army enlistment and built the first house in the Saucon Cross Roads vicinity, which later became part of Hellertown.

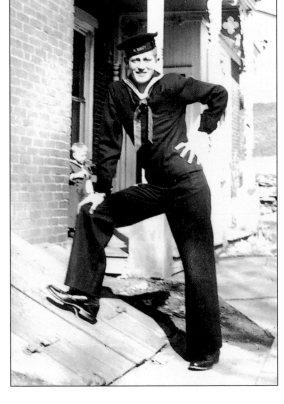

World War II took many Lower Saucon men and women into the South Pacific and European theaters of combat. This photograph features Sea-Bee Jake Mowrey, one of the many locals whose lives were interrupted by the patriotic call to defend the free world during the early 1940s.

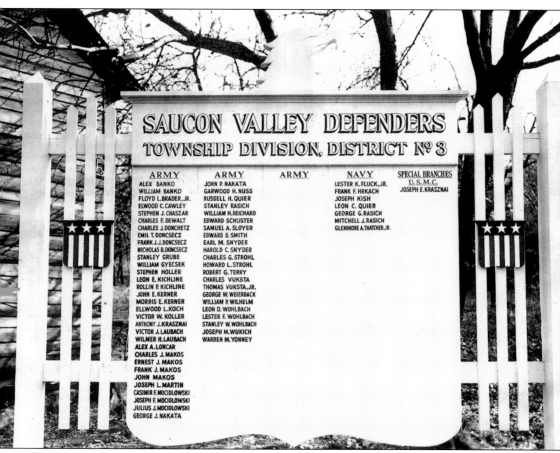

SAUCON VALLEY DEFENDERS
TOWNSHIP DIVISION, DISTRICT № 3

ARMY	ARMY	ARMY	NAVY	SPECIAL BRANCHES U.S.M.C.
ALEX BANKO	JOHN P. NAKATA		LESTER K. FLUCK, JR.	JOSEPH E. KRASZNAI
WILLIAM BANKO	GARWOOD H. NUSS		FRANK F. HRKACH	
FLOYD L. BRADER, JR.	RUSSELL H. QUIER		JOSEPH KISH	
ELWOOD C. CAWLEY	STANLEY RASICH		LEON C. QUIER	
STEPHEN J. CHASZAR	WILLIAM H. REICHARD		GEORGE G. RASICH	
CHARLES F. DEWALT	EDWARD SCHUSTER		MITCHELL J. RASICH	
CHARLES J. DONCHETZ	SAMUEL A. SLOYER		GLENMORE A. THATCHER, JR.	
EMIL T. DONCSECZ	EDWARD D. SMITH			
FRANK J. J. DONCSECZ	EARL M. SNYDER			
NICHOLAS B. DONCSECZ	HAROLD C. SNYDER			
STANLEY GRUBE	CHARLES G. STROHL			
WILLIAM GYECSEK	HOWARD L. STROHL			
STEPHEN HOLLER	ROBERT G. TERRY			
LEON E. KICHLINE	CHARLES VUKSTA			
ROLLIN P. KICHLINE	THOMAS VUKSTA, JR.			
JOHN E. KERNER	GEORGE W. WEIERBACK			
MORRIS E. KERNER	WILLIAM P. WILHELM			
ELLWOOD L. KOCH	LEON D. WOHLBACH			
VICTOR W. KOLLER	LESTER F. WOHLBACH			
ANTHONY J. KRASZNAI	STANLEY W. WOHLBACH			
VICTOR J. LAUBACH	JOSEPH M. WUKICH			
WILMER H. LAUBACH	WARREN M. YONNEY			
ALEX A. LONCAR				
CHARLES J. MAKOS				
ERNEST J. MAKOS				
FRANK J. MAKOS				
JOHN MAKOS				
JOSEPH L. MARTIN				
CASIMIR F. MOCIDLOWSKI				
JOSEPH F. MOCIDLOWSKI				
JULIUS J. MOCIDLOWSKI				
GEORGE J. NAKATA				

This plaque honored active World War II servicemen from Lower Saucon Township. It was displayed at the Cross Roads at Wassergass (Ironville), on the property of Alvin J. Redline, in Lower Saucon Township. It was designed, erected, and constructed by John Gilmore of 133 Roth Avenue, Hellertown, and made possible by a board of governors consisting of chairman Jacob S. Raab, Mrs. Floyd Brader Sr., Mae I. Quier, and Mrs. Clarence Reiss Sr., and the contributions of the residents of the area.

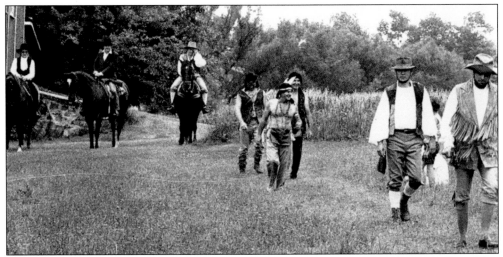

This view shows a re-creation of the Walking Purchase, when Edward Marshall and his associates, along with the Lenape Indians, traversed Leithsville to the Lehigh River in 1737. Ethel Helms wrote the play for the Wassergass Bushmen to perform. This scene took place during the bicentennial celebration of Lower Saucon Township in June 1976.

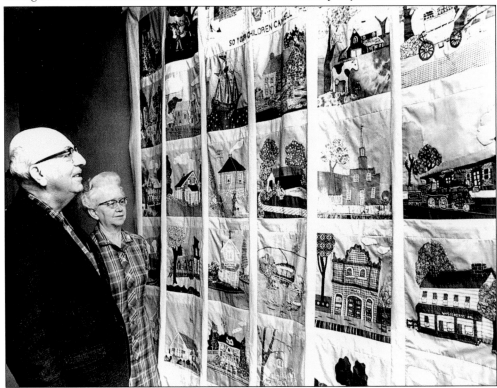

The bicentennial quilt of 1976 commemorates significant landmarks in Lower Saucon Township and Hellertown. It currently hangs in the Hellertown Borough Hall for the public to view, thanks to the work crew of the Hellertown Historical Society. Shown here are Herbert Weisel and Martha (Judd) Clarke. Plainly visible on the quilt are the Lutz Franklin Schoolhouse and Bergstresser's General Store.

Local historian Ethel Helms is shown speaking at the 1974 Heritage Festival. She said, "I am a staunch defender of historic preservation. I feel that with the rate that change is coming upon us historic preservation values can help us cope with tomorrow and that our historic landmarks are functioning reminders of this change that is coming upon us. Even in the Bible, I notice the Book of Proverbs, Chapter 22, verse 28 admonishes, 'Remove not the ancient landmarks.' "

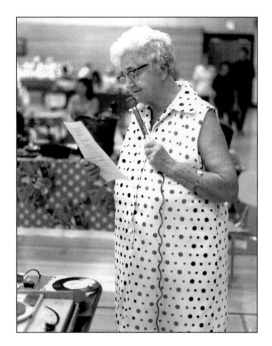

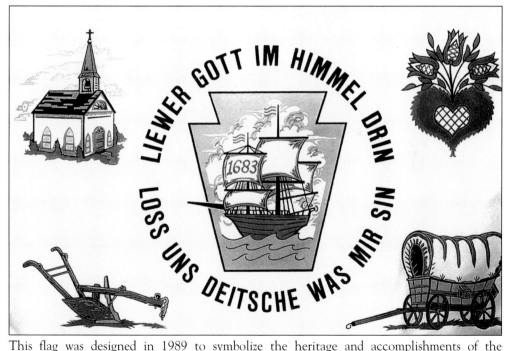

This flag was designed in 1989 to symbolize the heritage and accomplishments of the Pennsylvania German settlers. The ship *Concord* brought the first German immigrants to America in 1683. The keystone stands for Pennsylvania, where most of the Germans settled. The translation of the expression reads, "Dear God in Heaven, Leave Us Germans What We Are." The church symbolizes the group's devout character. The plow indicates the dominant occupation of farming. The Conestoga wagon stands for their role as teamsters in the American Revolution. Finally, the heart and tulip symbolize the German influence in arts and crafts.

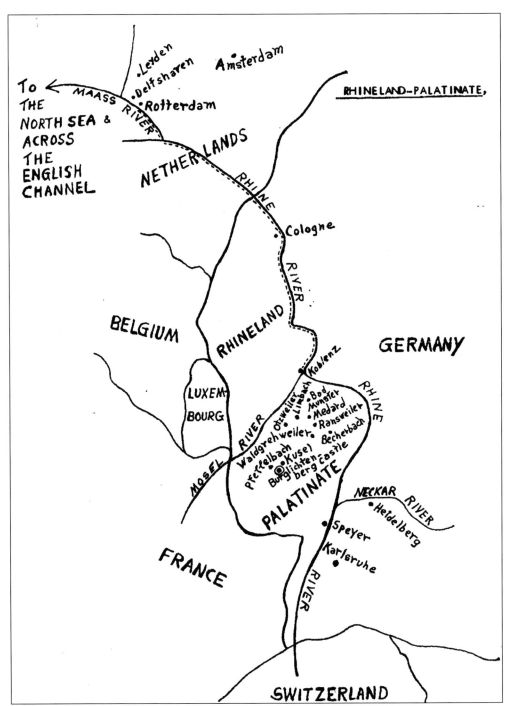

Many of the first German immigrants entered the Lehigh Valley by way of Lower Saucon Township and remained there due to the similarity of the land to that of the Palatinate region of Germany. They had left Germany to escape religious persecution and conscription into various armies against their will, or in response to William Penn's vast advertising throughout Germany.

Two

PLACES OF WORSHIP

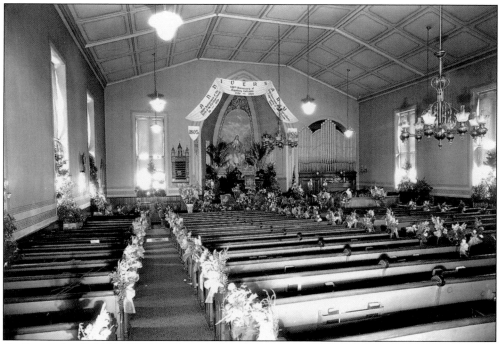

On September 7, 1930, Christ Lutheran Church Lower Saucon celebrated its 125th anniversary. Rev. Robert H. Krauss was pastor. In addition, the church acknowledged the 400th anniversary of the Augsburg Confession, the most widely accepted Lutheran statement of faith. Also at this time, Christ Lutheran celebrated the 1,900th anniversary of the Christian Church, and appropriately decorated the house of worship in banners and flowers.

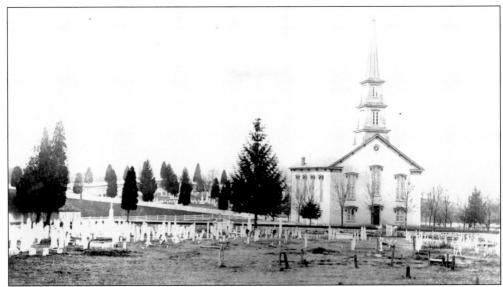

Christ Lutheran Church Lower Saucon is one of the oldest congregations in Northampton County, having built its first log church in 1751. The present church, third to be built on this Easton Road site, was dedicated in 1873. A one-room schoolhouse and old graveyard are across the road. The school was rebuilt in 1881 and now houses the pastoral office for the church. A dedicated group of quilters meets every Tuesday in this old schoolhouse.

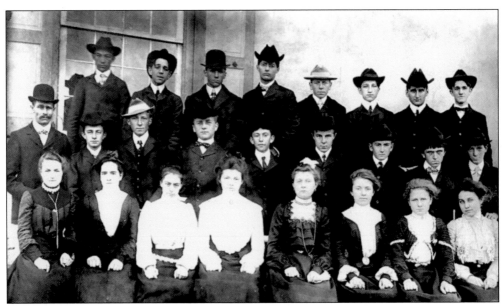

The Christ Lutheran confirmation class of 1902, taught by Rev. William J. Bieber, includes, from left to right, the following: (first row) Carrie Achey, Emma Bauder, Clara Muschlitz, Susie Reinbold, Cora Heft, Irma Wasser, Ida Eckert, Stella Unangst, and Mertie Bauder; (second row) Arthur Bader, Harvey Bauder, Charlie Fluck, Walter Fluck, William Gross, William Harris, Aaron Hinkel, Archie Koplin, and Maurice Lambert; (third row) John Pfeiffer, Jacob Schaeffer, William Seifert, William Schere, Llewellyn Wilder, Elmer Werkheiser, James Witmer, George Ziegenfuss, and Nathan Ziegenfuss.

Confirmands of Christ Lutheran Church Lower Saucon received a certificate commending their profession of faith in the Lord Jesus Christ. The quotation at the top of the certificate reads, "Be thou faithful unto death." This document, dated November 13, 1869, records that Milton Werst was confirmed by Rev. W. R. Hofford, pastor from 1863 through 1870.

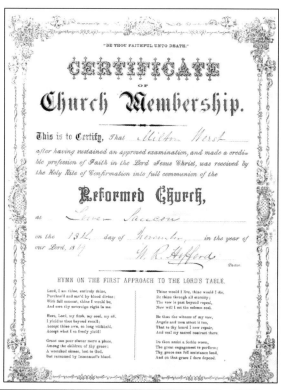

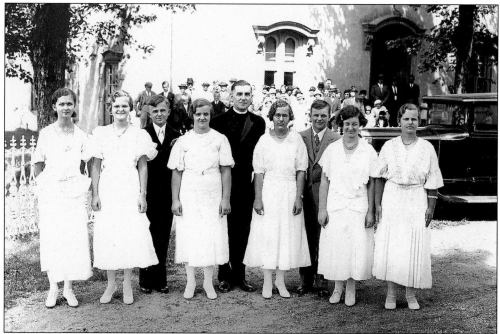

The Christ Lutheran confirmation class of September 17, 1933, features, from left to right, Evelyn Strawn (president), Catharine Rosenberger (vice president), William Shimer (secretary), Edith Shimer, Rev. R. H. Knauss, Helen Werkheiser, Floyd Hinkle (treasurer), Eleanor Seifert, and Thelma Keichel.

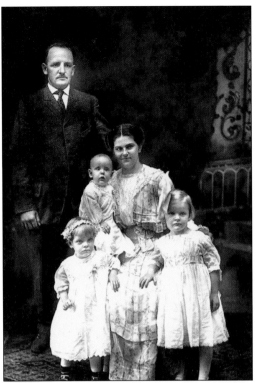

Thomas Hinkel, on mom's lap, was baptized at Christ Lutheran Church Lower Saucon on July 2, 1916. The Hinkel family members donned their best clothes for this special occasion. Rev. A. B. Koplin served the church for nearly 40 years and most likely baptized Thomas Hinkel.

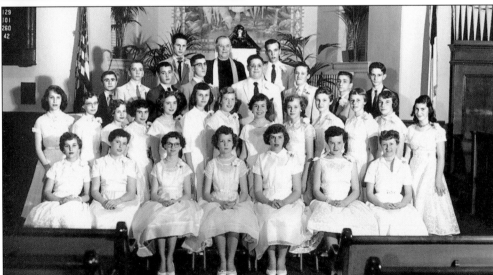

On Palm Sunday 1956, these youngsters were confirmed at Christ Lutheran Church Lower Saucon. Pictured here are, from left to right, the following: (first row) Rachel Petran, Patricia Smodish, Helen Berstresser, Jo Ann Schneider, Barbara Germanton, Mary Ann Wagner, and Carol Henman; (second row) Betty Bauder, Jan Wambold, Nancy Korn, Patricia Korn, Joyce Ziegenfuss, Helen Bauder, Joan Homer, Judy Calvert, Janet Goldman, Karen Barnett, Elaine Brader, Gene Sterner, and Gertrude Allio; (third row) Richard Korn, Joseph Jani, John Goldman, Richard Petran, David Gerstenberg, Ira Weierbach, Frank Jani, and Albert Schneider; (fourth row) Leland Riechard, Rev. R. H. Knauss, and Richard Goldman.

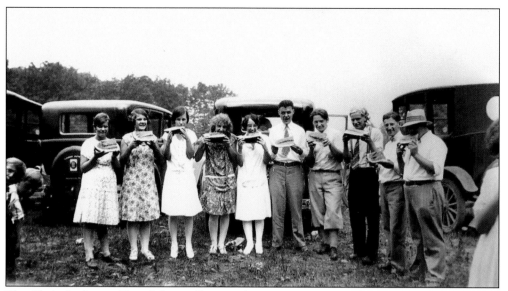

The Christ Lutheran Church Lower Saucon choir enjoys a watermelon-eating contest.

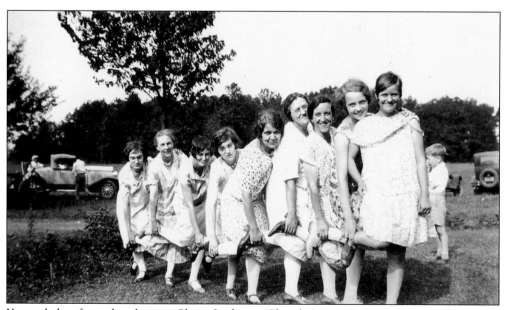

Young ladies from the choir at Christ Lutheran Church Lower Saucon take time from their Sunday outing to pose for a photograph, likely sometime in the late 1920s.

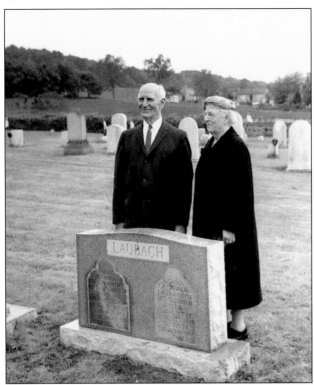

Frank C. and Effie (Seely) Laubach stand behind the granite monument created by the Laubach Family Association in honor of Lower Saucon's early settler Johann Christian Laubach and his wife, Susanna Catharina (Zimler) Laubach. The original tombstones of Christian and Susanna are embedded in the 1961 monument at Christ Lutheran Church Lower Saucon Old Cemetery. Frank C. Laubach began the "Each One Teach One" literacy method. He was honored with a 1984 U.S. postage stamp in the Great American series.

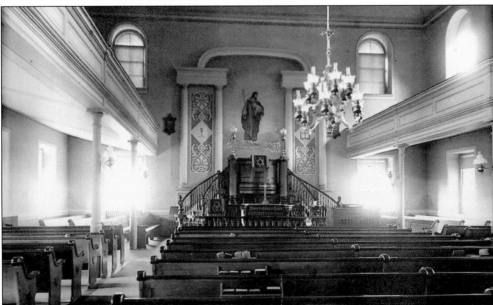

The interior of New Jerusalem Evangelical Lutheran Church has been meticulously cared for throughout the past 174 years. The original gas chandelier still hangs graciously in the center of the church, though gaslight was no longer needed when electricity was added in 1939. The painting above the pulpit, *The Ascension*, was a gift from the Sunday school in 1949. The high pulpit is a reminder of the Reformed congregation that was present until the union church was dissolved in 1951.

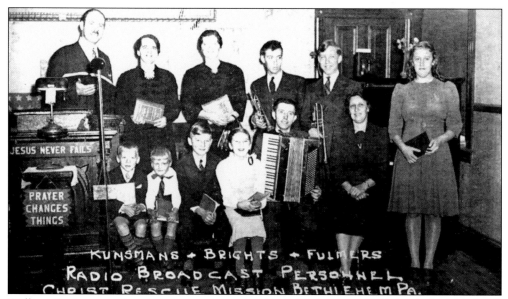

William E. Kunsman founded the nondenominational Christ Rescue Mission in January 1930. Sunday afternoon services were broadcast on radio station WEST in Easton. In this photograph, the Lower Saucon and Hellertown families of Kunsman, Bright, and Fulmer perform during the program "Comfort for All," likely during the 1940s.

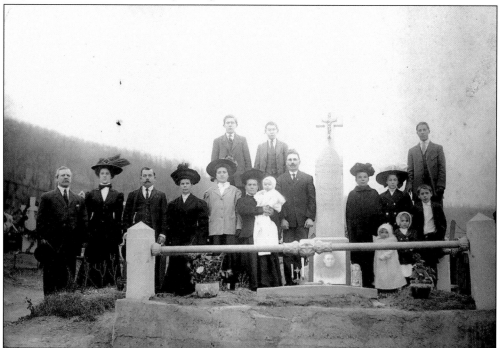

Maria Ringhoffer was interred at St. Michael's Cemetery in South Bethlehem in 1909. This photograph includes members of the Ringhoffer family such as Maria's son John (in the back row), her nephew John (in the front right), and Mary and Anna (to the right of the cross). The young children are Mary's daughters Johanna and Katherine. Maria's son George, about 10 years old, is on the extreme right.

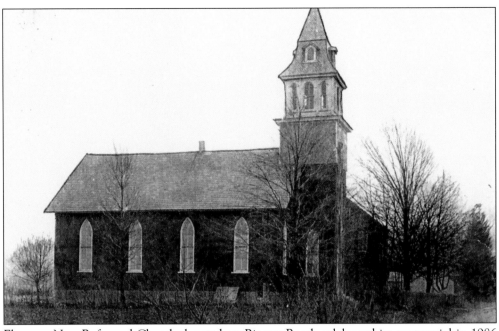

Ebenezer New Reformed Church, located on Bingen Road, celebrated its centennial in 1986 with Rev. Keith Easley as pastor. The once brick church was part of the Springfield charge, which included Mount Carmel Church in Pleasant Valley and Grace Church in Springtown. Ebenezer Church is now independent. The brick has since been replaced with stucco.

CONCERT
AS PART OF
100th ANNIVERSARY CELEBRATION
OF
NEW JERUSALEM (APPLES) CHURCH
LEITHSVILLE, PA. BY
POTTSVILLE LADIES' CHORUS
ASSISTED BY
MARTHA ADAMSON - SOPRANO
CHARLES WEISS - BARITONE
THURSDAY EVENING, MAY 24, 1934 — 8:15 D.S.T.

COMPLIMENTARY

Many complimentary tickets were printed for various church social functions in the township. On May 24, 1934, the New Jerusalem (Appel's) Church 100th anniversary celebration concert featured the visiting baritone Charles Weiss of Bingen, who had a professional music career in addition to operating the well-known Weiss' Store.

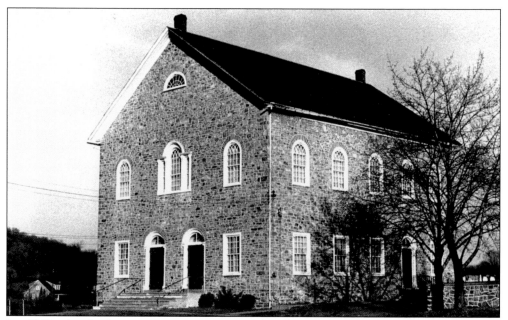

In 1763, the Lutheran congregation in Leithsville worshiped in Henry Schaffer's log schoolhouse. With the 1791 donation of an acre of land by John Appel and his wife for the purpose of a schoolhouse and place of worship, Lower Saucon's New Jerusalem Evangelical Lutheran Church was born. In 1834, the present building was erected and the education wing added in 1968. The first pipe organ was installed by Mr. Heintzelman in 1849.

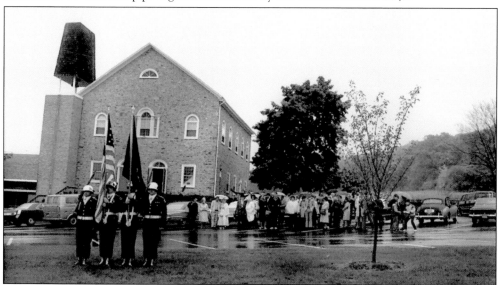

Appel's and Ebenezer New Reformed Churches gather for a centennial parade and celebration in 1986. The day marked Ebenezer's 100th year of worship in Lower Saucon. In 1886, the Reformed Congregation of Appel's and Ebenezer Reformed split, each forming its own church. The ROTC color guard led the parade, complete with horse-drawn carriages, Civil War Club members, and antique cars. Founding pastor Rev. J. M. Hartzell is buried in the cemetery behind the church. Since Hartzell, 16 other pastors have served this congregation, including Reverends Hicks, Hancock, and Easley.

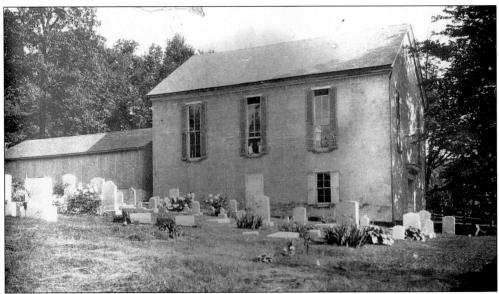

Trinity Church, situated in the part of Lower Saucon called Ironville on land once owned by Peter Wasser in 1870, now stands in disrepair. By action of the Northeastern Conference of the Evangelical United Brethren Church, the Trinity congregation merged with St. Paul's in Hellertown in 1958. In December 1962, the cemetery was sold for $1 to the Trinity Cemetery Association and the church building to Rollin P. Kichline of Lower Saucon for his private residence.

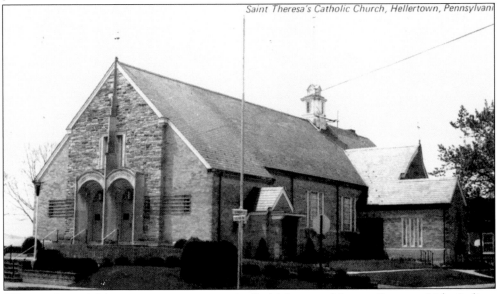

When industrial labor opportunities arose in Bethlehem and Lower Saucon, Irish, Italian, and Slavic immigrants quickly increased the population of the township. There was a need to worship in the Catholic faith, yet no such churches were close by. In 1854, the first Catholic Mass was held in a home in Hellertown, then part of Lower Saucon Township. It was not until 67 years later that a mission parish would be formed under Saints Cyril and Methodius. The mission would be given full Canonical status and renamed St. Theresa of the Child Jesus four years later.

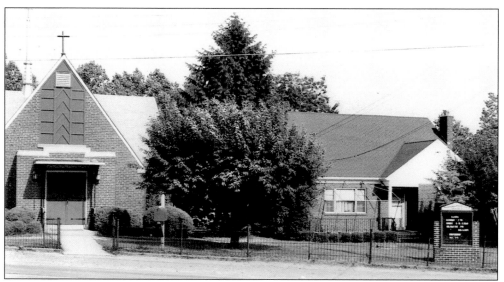

In 1920, the nearest Catholic parish was St. Ursula's in Bethlehem, causing five families to create a mission church using Fritz's Memorial Church in Colesville. In 1927, St. Joseph's Catholic Chapel (above) was built by five founders (below). The founders are, from left to right, Martin Connor, Martina Connor, Ellie Hasson, Ben Schrader (the contractor) and his son, Jim Hasson, Patrick Kelly, Michael McGovern, and William Allen. In 1952, under Pastor William Drobel, St. Joseph's Chapel became the diocesan Church of the Assumption Blessed Virgin Mary. A church addition united the old chapel and a new church in the shape of a cross. The convent later became a rectory, and the existing rectory (above) was moved across the street. Today, an elementary school and 1,300 families contribute to its sense of community while still maintaining its original quaintness.

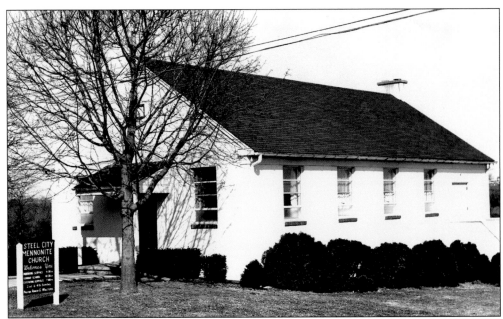

Steel City Mennonite Church (above) began in 1951 as an outreach of the Franconia Mennonite Conference. It was first located in a room above a garage on Gawell Street. The church was founded by the Benner, Bergey, Greaser, Freed, and Landis families (some of whom are standing in the photograph below). A new church building was erected in 1955 and is now used for a chapel and multipurpose room. An adjoining fellowship hall, school, and sanctuary building was completed in 2000. The Mennonites are a Bible-believing congregation focusing on Jesus Christ's teachings about loving our enemies. Pastors of the church have included Harold Fly, Frank Greaser, Bob Walters, Duane Frederick, and David Kochsmeirer. The preschool of the Bethlehem Christian School is housed in the building. Members come from Easton, Nazareth, Hellertown, and Allentown to worship at Steel City Mennonite Church.

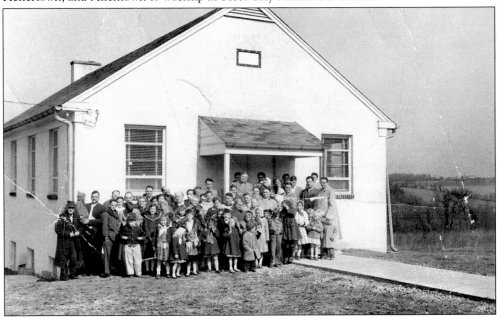

Three

TRANSPORTATION

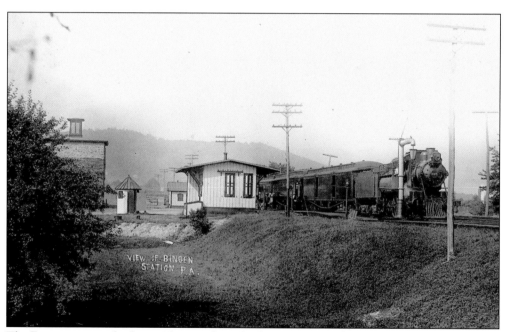

The Bingen station, built *c.* 1850, significantly changed the economic climate of Bingen. Feed, brought by freight, would arrive at Ehrhart's Mill to be ground and sold. Freight cars also brought coal to Harry Hafler, a dealer in anthracite and bituminous coal.

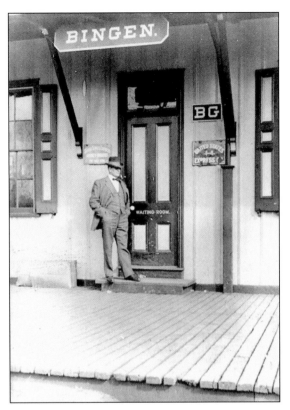

Myron Landis of Station Avenue in Coopersburg served as the Bingen station master. The U.S. Census shows Landis as telegrapher in 1910 and station agent from 1920 to at least 1930. It was common for one man to perform both the telegrapher and station agent duties. The depot telegrapher was the air traffic controller of the railroad industry. Western Union supplied the depot with telegraph equipment, while the railroad paid the operator. Eventually, the telephone replaced the telegraph, and the Bingen station was removed for economic reasons.

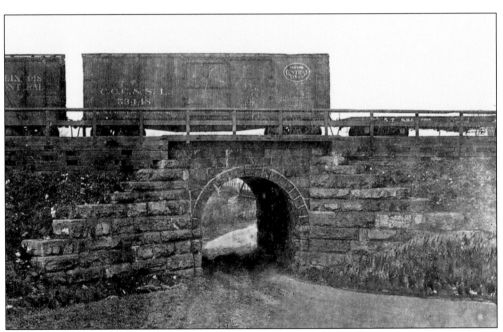

The railroad overpass in Bingen was rebuilt in the 1960s to better accommodate school buses. At the same time, Bingen Road was straightened out, the tunnel was removed, and Reading Road was moved about 50 feet.

Richard L. Kantor, one of the prime movers of the original Lower Saucon Township Historical Society, examines some data from the Hellertown train station. Kantor is one of the leading authorities on local history and taught at the middle school in Hellertown for many years. He was instrumental in writing the *Lookback*, the Bicentennial Quilt book, and the Hellertown Bicentennial book. Kantor also taught local history classes to adults in the community.

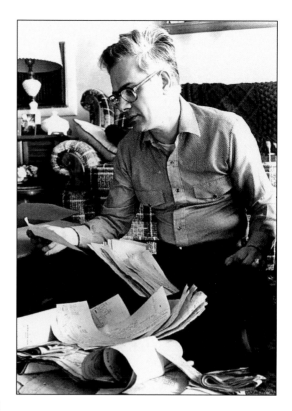

Clarence Ehrhart of Ehrhart's Mill, seen here in 1941, was a friend of Herbert "Hop" Achey of Hellertown. Hop received his nickname due to his ability to play pool; he was able to hop one ball over another in order to make a crucial shot.

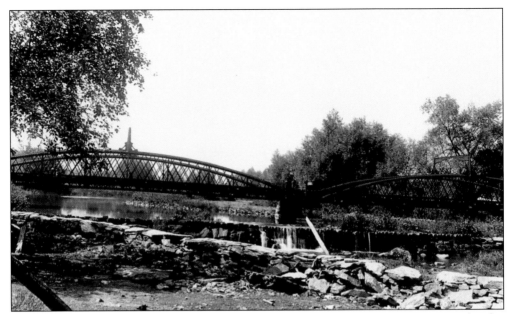

The Old Mill Road bridge, an iron Pratt-truss structure erected in 1867, is considered a significant historic bridge because of its cast lower-chord connections. In addition, it is one of the oldest all-metal bridges in the country. It was erected at a cost of $2,400 for ironwork and $750 for masonry. The bridge is adjacent to Ehrhart's Mill and once provided an important access. It was closed to automobile traffic in 1983 because of cracks in the deck beams.

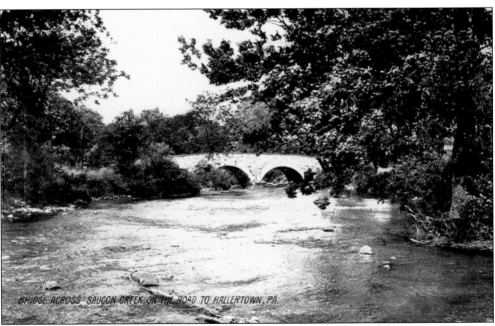

This fieldstone bridge spanning the Saucon Creek on Meadows Road was built in 1858. It is 102 feet long and carries two lanes. The four spandrel arches give this bridge its historic character.

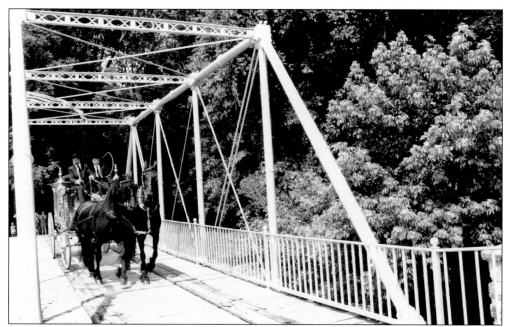

The Walnut Street Pony Bridge once spanned the Saucon Creek, connecting Hellertown to Lower Saucon Township. Built c. 1860, it is the only high-truss span built by the Beckel Iron Foundry in existence today. This is a historically significant bridge that once provided important access to the nearby Wagner Gristmill. It was removed from service in 1970 and was reassembled and restored as a pedestrian bridge a short distance away by the Hellertown Historical Society and Lehigh University engineering personnel.

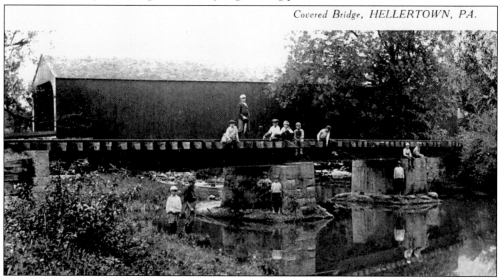

Pictured here from left to right, Howard Hess, Harry Weirbach, Stuart Frantz, Titus Bergstresser, and Elroy Harwi enjoy their favorite fishing spot c. 1915. This covered bridge and railroad trestle spanned the Saucon Creek a short distance west of the current Water Street bridge. The railroad trestle was used by the Thomas Iron Company to bring limestone from the west bank of the Saucon Creek to its furnaces, once located behind the present Saucon Valley Manor. Its piers are still visible today. The bridge was torn down in 1939.

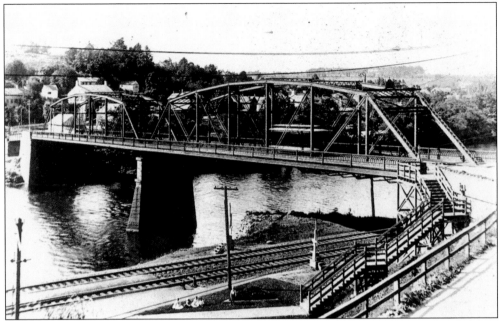

This bridge spanned 22 feet wide and 360 feet long over the Lehigh River, connecting Steel City to Freemansburg. Replacing a covered bridge, it was built by the Groton Bridge Manufacturing Company in 1896. This bridge in turn was replaced by the modern cement bridge in use today.

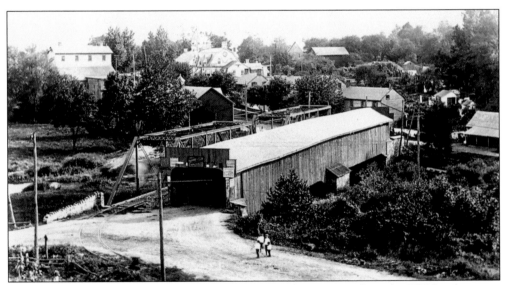

This southward view of the Shimersville village was taken *c.* 1900 from the PP&L substation. Two bridges stand side by side: a steel and a covered bridge. Trolleys transporting people between South Bethlehem and Easton traveled through the steel span. The tracks are visible in the lower left of this photograph. The road in the lower left is Applebutter Road, and the road along the bottom ran to Steel City and the Freemansburg Bridge. Knechts Mill is the large building on the left, and the Laudenberger residence is in the center. The village blacksmith occupied the building on the far right. By 1910, the covered bridge had been removed, according to former Shimersville residents.

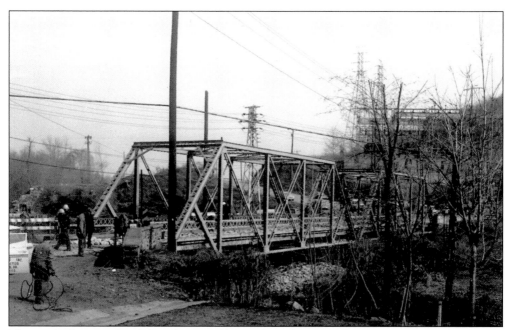

This rare photograph of the Shimersville Steel Bridge over the Saucon Creek depicts the beginning of its demolition in 1968. The former site of the Shimersville Ironworks of the 19th century rested off Applebutter Road, to the right of this bridge. To the left, a motorist could head toward Steel City or travel the bridge over the Lehigh River to Freemansburg.

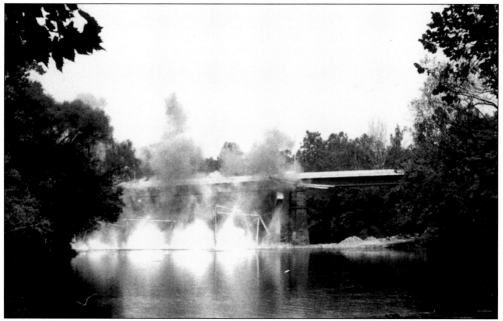

The Freemansburg Bridge, built in 1896, was detonated in September 1998, and the steel arch plunged into the Lehigh River. The bridge was replaced by a new, four-span steel I-beam with a 30-foot-wide pavement and a 5.5-foot-wide sidewalk. Lower Saucon Township councilwoman Priscilla DeLeon and state representative Robert Freeman were present for the dedication of the adjacent new bridge shortly afterward.

This 1936 photograph shows, from left to right, Russell Diehl, Helen Ellis, Mary Ortwein, and two unidentified Route 12 highway builders. The road ran parallel to the village of Seidersville.

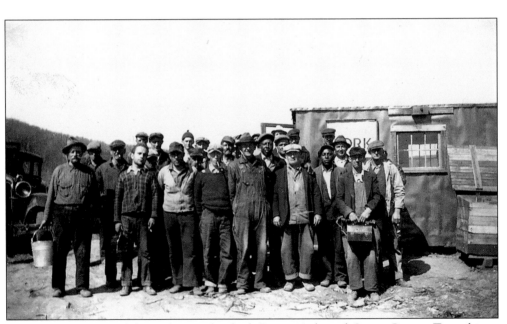

These men were part of the work crew that built Route 12 through Lower Saucon Township at Seidersville. Later, the road was renamed Route 191 but today is known as Route 378. Route 378 begins at Route 309 in Coopersburg and extends north to Route 22 in Bethlehem.

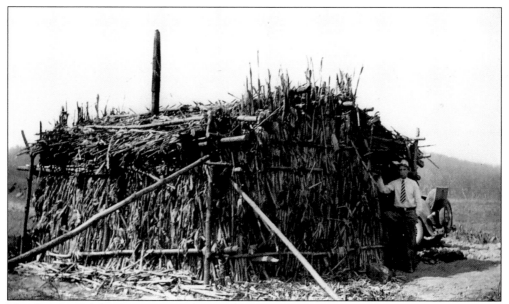

The foreman of the Route 12 road crew through Seidersville stands outside the door to his office, made of corn stalks.

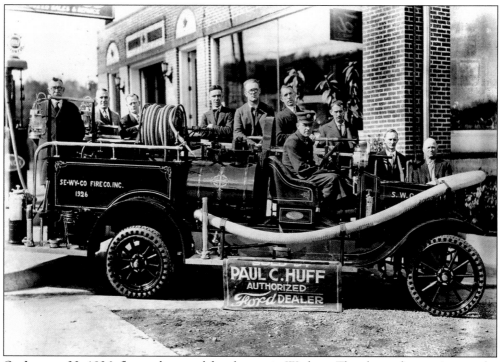

On January 30, 1926, flames destroyed four homes in Wydnor. The closest fire service was the Liberty Fire Company in Bethlehem. Because of this disaster, a fire company was formed to serve Seidersville, Wydnor, and Colesville. It was named the SE-WY-CO Fire Company. By the fall of the same year, a Model T Ford became the first fire truck.

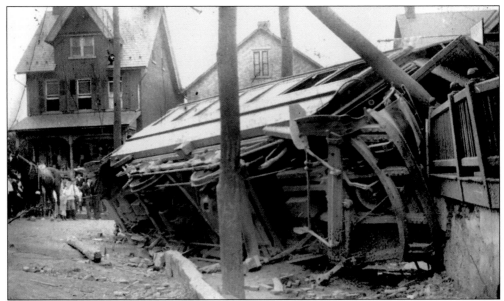

From 1909 to 1929, the South Bethlehem and Saucon Street Railway Company ran a service between South Bethlehem and Center Valley. The transit company used the same route as the stagecoaches in years past. The journey for the yellow and green trolley cars started in Center Valley, passed through Friedensville, Colesville, and Seidersville, and ended at the Sun Inn in Bethlehem. Because of the steep grading of the track over South Mountain, the line experienced breakdowns and out-of-control cars in bad weather. Taken on October 13, 1918, this photograph shows a trolley car that ran off the track and crashed into a dwelling at the intersection of Wyandotte and Summit Streets. When the city of Bethlehem initiated a street-paving project in 1928, the transit company abandoned its service.

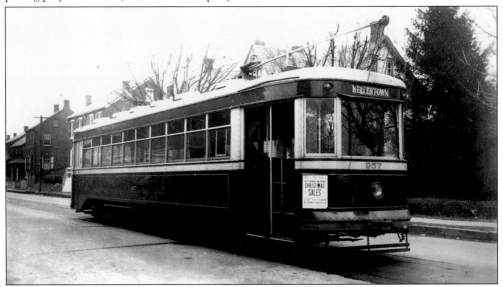

The residents of Lower Saucon Township were served by the Lehigh Valley Transit Company from 1897 to 1952. The company offered a route that included stops at Hellertown, Crest Avenue, Rentzheimer's Cave, Northampton Heights, South Bethlehem, and Bethlehem. Here, car 957 is en route to Hellertown in 1930.

Four

INDUSTRY AND
AGRICULTURE

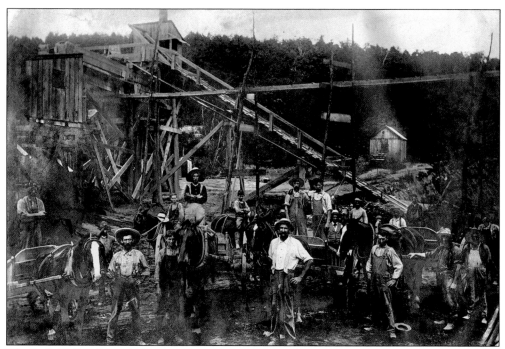

The Polk Valley (Koch) Hematite Mine was just one of many iron ore mines in Lower Saucon Township. Others included the Gangewer, Hartman, Weber, Desh, and Martin Mines. Hematite is a reddish-brown or black mineral consisting of ferric oxide, an important iron ore found in crystals or as earthy red ocher.

Dr. H. D. Heller's limestone quarry was located on the Saucon Creek's west side, near the Heller homestead. Heller supplied limestone to the Thomas Iron Company at 50¢ per ton. According to Hellertown historian Richard L. Kantor, "One of the workmen can be seen pushing a load of stone across the loading wharf, where it was dumped into railroad cars in the lower right portion of the photograph. An engine from the iron company later pulled these cars to the local furnace." In 1908, there were 23 men working six days per week.

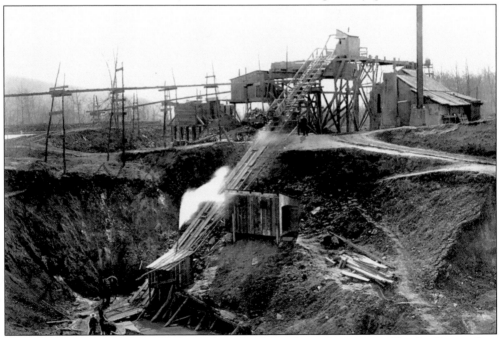

The Koch Brown Mine, located along Silver Creek Road, was first operated by the Saucon Iron Company and later by the Thomas Iron Company until 1907. Brown hematite was a low-grade limonite ore. The hoist in the open-pit mine raised the ore cars to the separation and washing area. The ore was then transported to the furnaces.

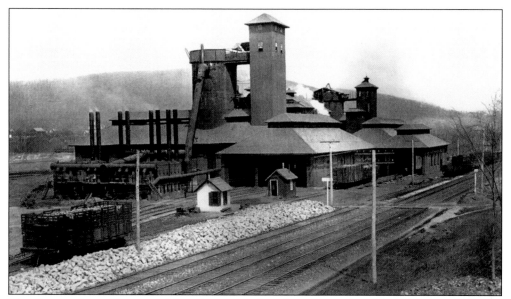

The Saucon Iron Company (above) was purchased on December 13, 1884, becoming the Thomas Iron Company. Saucon Iron had been chartered in 1866 by Jacob Riegel, a Lower Saucon Township native. The furnaces at this location were built with sheet-iron shells resting on cast-iron columns, an innovation after the Civil War. The Thomas Iron Company ceased operation in 1920. In this c. 1910 photograph, several cars are loaded with coke obtained from western Pennsylvania.

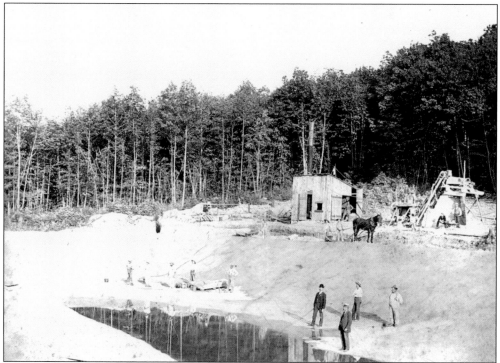

This 1898 photograph shows the initial excavation of the Hellertown Reservoir in Lower Saucon Township.

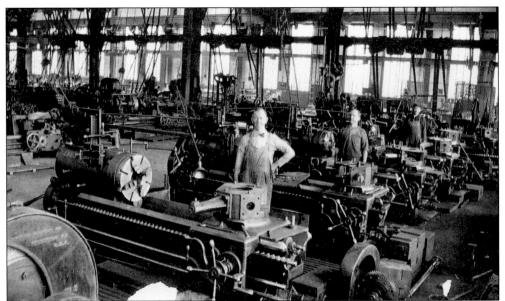

In 1916, Bethlehem Steel built four large buildings for its munitions plant in Redington. During World War I, this plant produced 25,000 shells a day. More than 690 men were employed to manufacture at least five different size shells. At the end of the war in 1919, the munitions plant and proving grounds were closed.

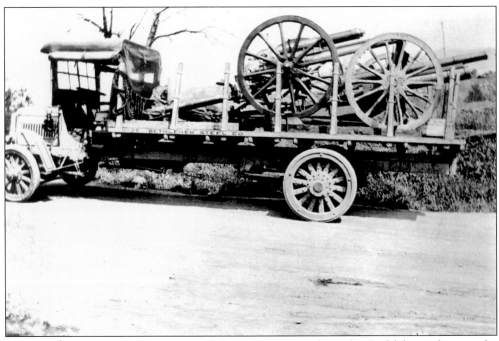

Bethlehem Steel Company trucks hauled artillery pieces from the Bethlehem plant to the Redington proving grounds for testing. The proving grounds were located on the south bank of the Lehigh River in Lower Saucon Township. After the Coleraine Iron Company closed in 1893, Bethlehem Steel purchased the site, and it was a testing area during the late 19th and early 20th centuries.

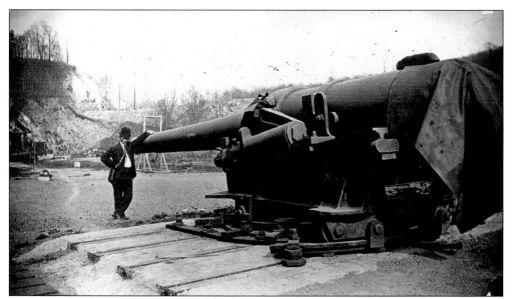

In 1912, the Redington Proving Grounds Division was organized for the purposes of testing guns and munitions. Guns were fired into the limestone cliffs. This blasting created large caves and tunnels, which can still be seen today. The Lehigh Valley Railroad started a station at Lime Ridge–Redington in 1859 (note the train that passes close to the grounds), opening the economic potential of Redington.

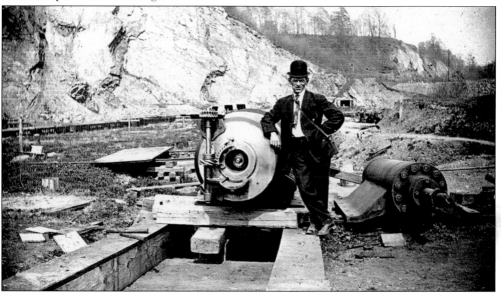

Austin Knauss worked as a well driller, and his wife, Hilda, was a teacher at the Wassergass School. They lived along Wassergass Road. Austin, the son of Owen and Ella (Ruch) Knauss, lived from 1902 to 1981.

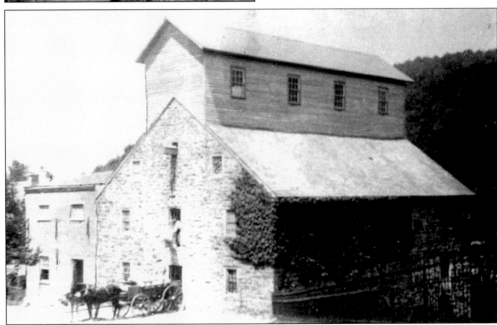

On Saucon Creek in 1738, Nathaniel Irish erected the county's first gristmill. Irish also built a home, sawmill, and office. He was employed as the agent for land sales to the Moravians in Bethlehem. Jacob Shimer bought the mill in 1812 and erected an oil mill to its south and a fulling mill, which his son George operated. The mill suffered damages and reconstructions throughout the 19th century, but today portions of its wall are all that remain near Applebutter and Shimersville Roads.

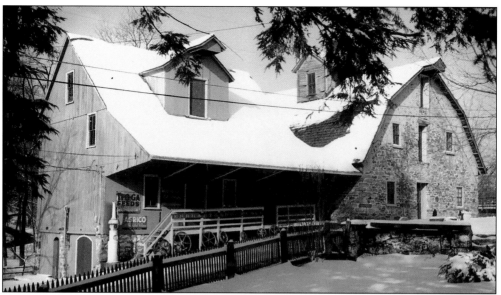

Ehrhart's Mill was bought from John, Thomas, and Richard Penn on July 23, 1744, by miller Christian Boeydler. On June 20, 1751, he sold it to Christian Bachman. Then, in 1792, it was acquired by the Mohr family and later by the Appel family. In 1877, the mill became the property of the Ehrhart brothers, Clarence and Stewart. In 1865, it burned down but was then rebuilt. However, arsonists set the mill on fire in 1995, leaving only the scale house and foundation.

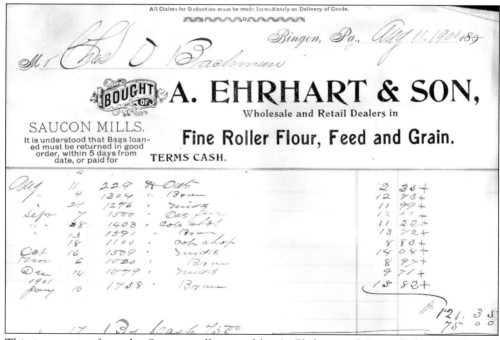

This is a receipt from the Saucon mills owned by A. Ehrhart and Son, wholesale and retail dealers in fine roller flour, feed, and grain in Bingen. The receipt is dated August 11, 1900, for materials sold to Charles Bachman. It states, "It is understood that Bags loaned must be returned in good order, within 5 days from date or paid for."

Sarah Ehrhart was born in 1836 and ran Ehrhart's Mill with her brother Joseph. Neither sibling ever married, living in the house across the street from the mill. Their younger brother Andrew, born c. 1840, moved from the family farm in Leithsville to take over the running of the mill. This enabled Sarah to retire in 1891. She then built the house and red barn located at 1859 Old Mill Road. Sarah passed away in 1929.

CLAREMONT PEACH GROVE.
CHOICE MOUNTAIN FRUIT.

W. J. SLEIFER,

DEALER IN

GENERAL MERCHANDISE.

Shipping Station, BINGEN, PA.

Saucona, Pa., SEP 23 1902 *19*

Mr. C. C. Bachman,
Dear Sir +
Since you requested me about Peaches, I asked Mr. Sleifer and he told me I should informed you begining of next week, should be about the best time to get such Peaches as you are wanting,

Your Respectfully
E. Z. Eisenhart
Saucona Pa.

On September 23, 1902, W. J. Sleifer of Bingen received a letter from E. Z. Eisenhart of Saucona concerning a peach order.

Jim Ravier stands at the old coal bins along Coal Yard Road in Bingen. He apparently has his sights on the famed baseball field nearby.

John W. Farley was born on September 12, 1857, and killed on July 9, 1872, in the boiler-stack explosion of the North Pennsylvania Iron Company in Bingen. He died two months before his 15th birthday. According to the 1870 census, he was the son of Isaac, an engineer, and Catherine and older brother to siblings Jacob, William, Edgar, and Catherine.

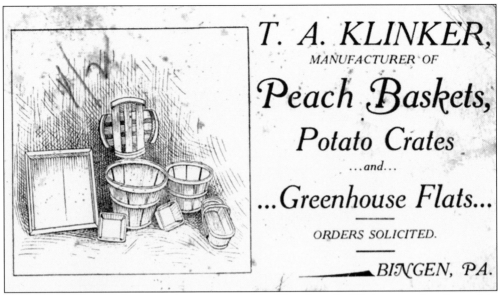

T. A. KLINKER,
MANUFACTURER OF
Peach Baskets,
Potato Crates
...and...
...*Greenhouse Flats*...
ORDERS SOLICITED.
BINGEN, PA.

The T. A. Klinker basket manufacturer, owned by Theodore A. Klinker, was first located in Bingen. During World War I, the business had to cut back production and relocated to the Saucon Cross Roads area of Lower Saucon Township. The company served many farms by providing crates for peaches and potatoes. Gangewer Greenhouses were also located in Saucon Cross Roads and most likely bought Klinker greenhouse flats.

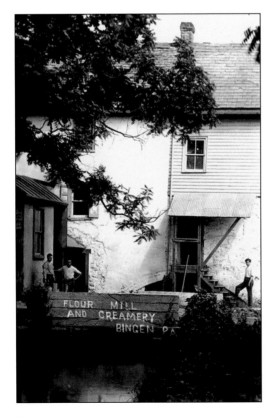

This postcard gives a rare glimpse of the flour mill and creamery in Bingen.

Lime was the key ingredient to highly productive farming among the German immigrants of Lower Saucon. When limestone was burned in a hot, wood-fired kiln, it shrunk in size and became lumps of "quick lime." Once cooled, larger lumps were saved for building materials. Wood ash and lime shards went to lime the fields. Water added to quick lime made it seem to "come alive" or "quicken" by swelling and heating up. This slaked lime was used to make mortar, plaster, and whitewash (*weisel-barshd*). Schroeder's Lime production patent was first used by Joseph Yeager of Bingen in 1855. Other lime burners were John Wagner and Leonard Landenberger near Hellertown, William R. Yeager at Bingen, and John Shimer at Shimersville.

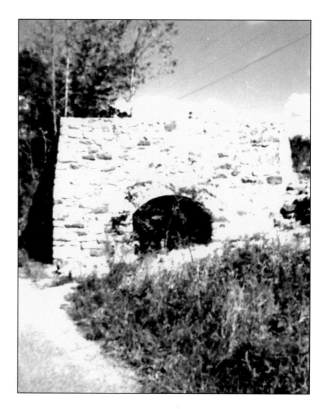

Workman Stewart K. appears here with a flax breaker. The fiber of the flax was manufactured into linen yarn for thread or woven fabrics. Flax seed was used to produce linseed oil.

Quincy and Deborah Bent acquired the white Colonial home seen above, once owned by the Gangewer family and now the Saucon Valley Guest House at Weyhill. Quincy's 500-acre dairy farm produced milk of four percent butterfat, an ideal mix obtained from combining that of Guernsey and Holstein cows (left). This milk won first prize in the State Farm Show in 1935. In addition, the farm contained 3,250 chickens, wild pheasants, and kennels for raising springer spaniels. An old iron mine a quarter-mile from the house was a popular lake-size swimming hole known as "Quincy Bent's Mine." Young boys would dive to the bottom, fill up a jug with water, cork it, and bring it home to their elders for medicinal uses, as the water was rich in iron and calcium.

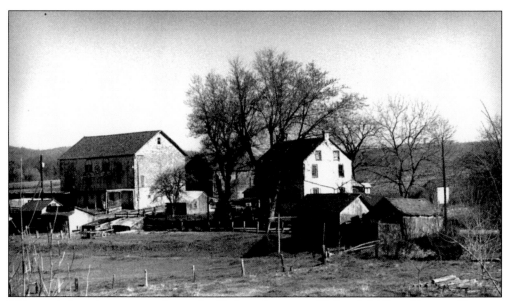

This rural Americana scene shows the Ehrhart farm near Ehrhart's Mill in Bingen. Clarence Ehrhart built the home in 1864 in the Greek Revival style. It was later sold to 1930s actress Patti Pickens of "the Pickens Sisters" as her retirement home. Pickens made a movie with Jack Haley, Ginger Rogers, and Jack Oakie called *Sitting Pretty*. She was married to Rev. Canon Charles Shreve, appointed in 1980 as canon in residence at the Episcopal Church of the Nativity in Bethlehem.

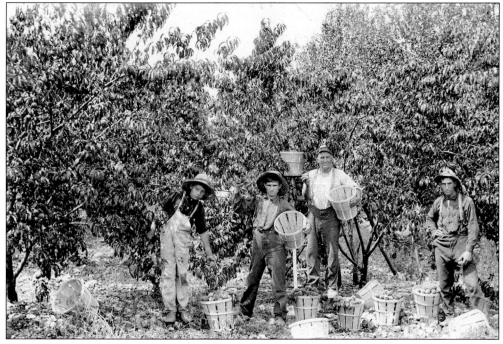

James Monroe Weiss owned this Leithsville peach orchard, located behind the Manorcore. Shown in this *c.* 1910 photograph are, from left to right, unidentified, John, Jim, and Jake Weiss.

The Ortwein farmhouse, pictured here, stood on a 20-acre farm in Seidersville. Bernie Ortwein remembers the old days of Seidersville well, when Toby Clauser's general store was just up the hill. The original homestead was built before 1825.

The old well house on the Ortwein farm still stands today.

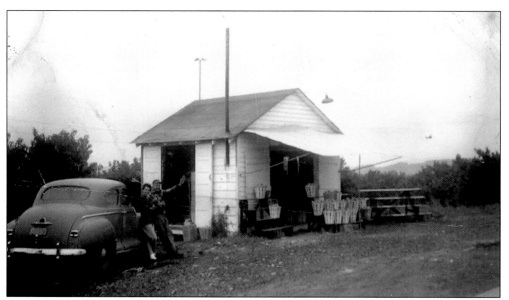

Bechdolt's Orchard began as an eight-acre orchard and small roadside farm stand on Route 412 in Leithsville. In 1947, William Rowe purchased the farm from John and Geraldine Bechdolt, who had bought it from original owners John and Elizabeth Wolst. Bechdolt's Orchard, now about 109 acres, is the largest fruit orchard in Northampton County. Shown in this photograph, Bechdolt's 1947 Plymouth was purchased at Robert E. Martin's car lot, now Black River Plaza on Route 378.

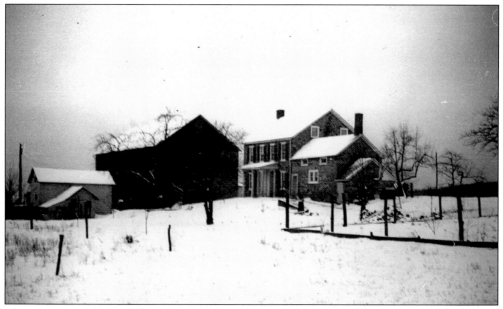

This farm, located along Reservoir Road, was owned by James T. Woodring until 1889. Jacob Rentzheimer then took ownership from 1889 until 1897. Next, his daughter Mary and her husband, Titus O. Bachman, resided here from 1897 to 1940. George and Ida Mar took possession from 1942 until 1977. Steve Mar lived here from 1977 to 1998. Currently, the remaining land and building belong to Stephen Roseman.

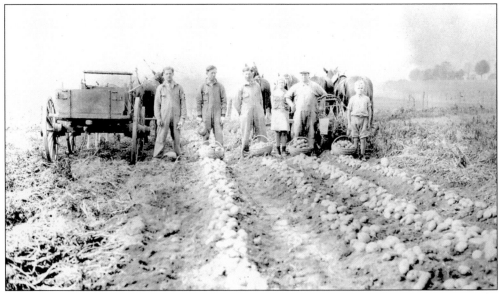

Men and women of all ages harvested potatoes on the Herman farm, currently occupied by the Saucon Valley School District campus. The high school was completed in 1971, followed by the middle and elementary schools in 1999. Today, the campus continues to expand as more farms are sold to housing developments and enrollment increases.

Unclassified
POTATOES
100 Pounds When Packed

GROWN AND SHIPPED BY

HERMAN BROTHERS
R. F. D. No. 1, HELLERTOWN, PA.

This rare tag for a bag of Herman Brothers potatoes was found in the former home of a Lower Saucon Township printer. The Herman farm was located on Polk Valley Road near Reservoir Road.

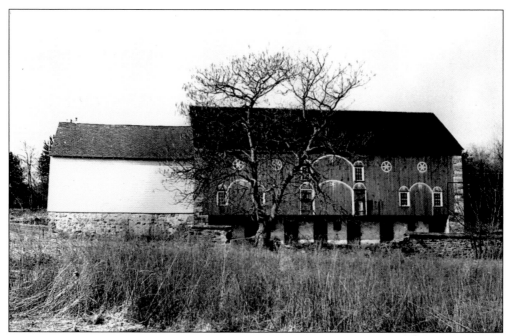

Built by Johannes Wagner in the 1840s, this stately barn stands on Meadows Road. The house would get very noisy and shake when the freight trains rolled by adjacent to the property.

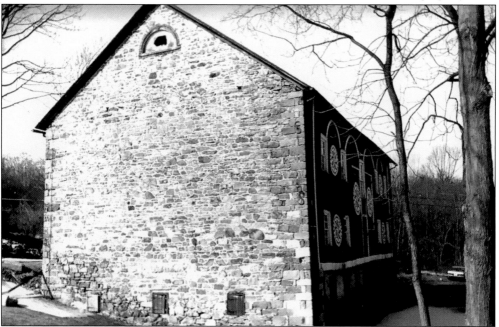

The Skibo farm dates back to the 1890s and is now eligible for listing in the National Register of Historic Places. In 1994, the Pennsylvania Historical and Museum Commission stated a high probability that the pigsty, barn, and residence could be a significant archaeological site. In addition, the buildings are a fine example of post-and-beam construction, with connections being made with the use of wood pegs. The homestead is opposite the Wagner Gristmill on Saucon Creek.

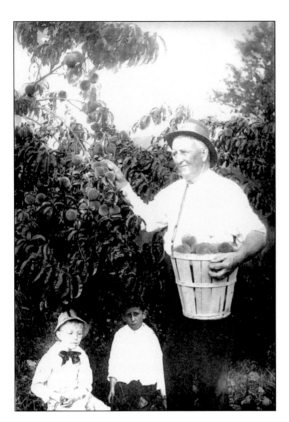

At the Weiss farm, James M. Weiss harvests peaches while Charles (left) and Paul S. Weiss sit in the shade.
The farm was west of Leithsville.

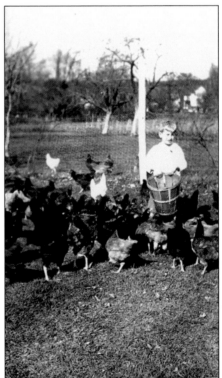

"Come one, come all," says Bernie Ortwein while feeding the chickens on his parents' farm in Seidersville.

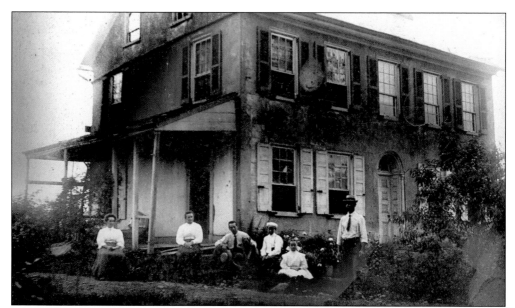

The Wirth farm has been family owned since the 18th century, with the exception of ownership by John and Mary Scotland from *c.* 1830 to 1860. John Scotland was a house carpenter. Since the doors on this home are identical to that of Trout Hall in Allentown and the interior staircase is identical to the railing at Appel's Church in Leithsville, Scotland was probably the craftsman for the woodwork on these properties as well. An educated guess places this photograph in the early 20th century, when the farm was occupied by Edwin and Alice Wirth and their three children: Althea, DonRoy Jr., and Dolores. Part of the farm on Black River Road became Interstate 78.

The E. Frank Coe Company of New York produced high-quality fertilizers such as Red Brand Excelsior Guano and Excelsior Potato Fertilizer. These products were sold by T. F. Kunsman in Lower Saucon. Within the pages of this notebook is a sale of four steers, two bulls, and four calves for a total of $469.27, registered to J. F. Kunsman.

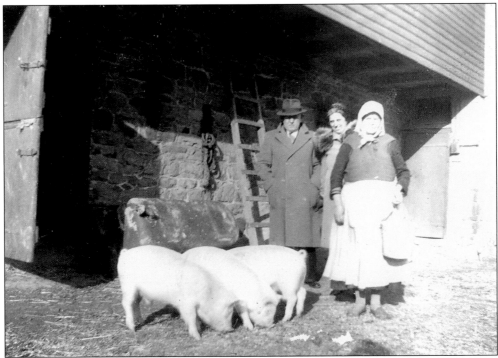

George and Ida Mar look on as Ida's mother, Lydia Horvath, feeds supper to the pigs on February 19, 1944.

Stephen Horvath digs out the foundation for the big new chicken house during the 1940s, when he resided on the Mar farm along Reservoir Road.

The farm truck is parked in front of the milk house on Robert Seifert's farm, located on Lower Saucon Road across from Polk Valley Road. Seifert grew oats, wheat, corn, and hay to feed the livestock.

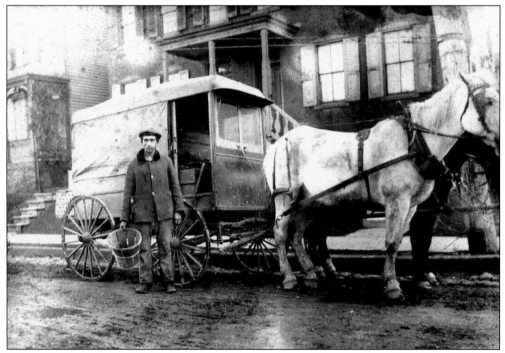

Robert Seifert also made his living by growing vegetables to sell at Bethlehem's South Side Market on Third Street and at his roadside stand in the township. This photograph was taken c. 1912.

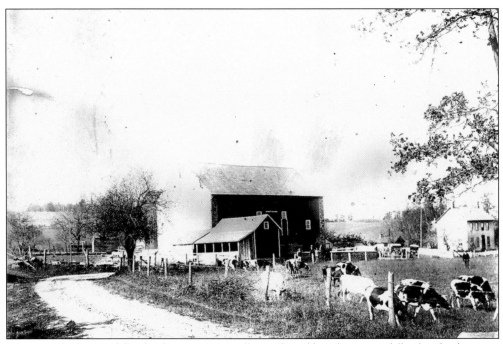

Harvey and Alice Wohlbach's farm was originally purchased by Clinton Wohlbach. The farm was given to Stanley Wohlbach of Hellertown by his cousin Pauline Wohlbach on August 15, 2003.

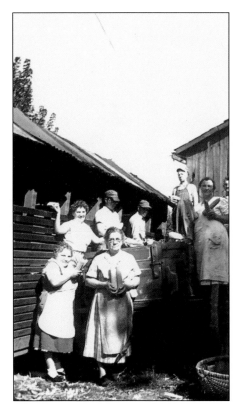

Corn is unloaded in October 1960, harvest time on the Wohlbach farm. Standing are Gloria and mother Mabel Wohlbach, Anna Judd, nephew Leon, uncle Harley, and Dorsey Wohlbach. Ernest Judd appears in the background. Aunt Sarah Wirth stands on the wagon wheel.

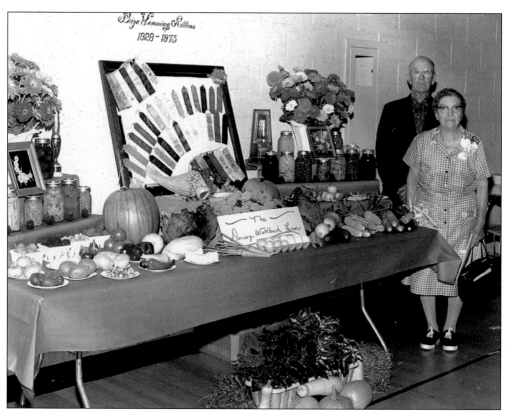

Dorsey and Mabel Wohlbach display their award-winning produce at Farm Day at Saucon Valley High School in 1974. The ribbons were won over the years from various agriculture fairs between 1928 and 1973.

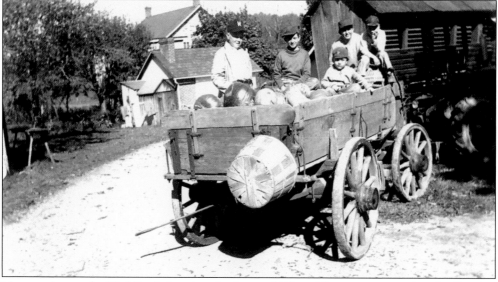

Harvest time at the Wohlbach farm involved area children. This group assisted in the October 1955 harvest of field pumpkins and in the annual Corn Husking Bee. Pictured are David, Leon, and Dennis Wohlbach, along with Bobby and Tommy Stout.

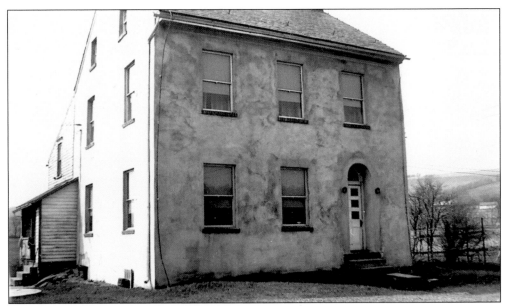

George and Ella Litz Ringhoffer farmed 62 acres of land on Ringhoffer Lane, just off Rinker Hill Road (now Ringhoffer Road). They farmed potatoes, cabbages, corn, alfalfa, wheat, and oats, which were then sold to Ehrhart's Mill. They also owned sheep, 50 cattle, ducks, and chickens. George purchased the farm in 1930 to feed his growing family after the stock market crash of 1929. The family had one of the first bathrooms in the township. In 1944, Bethlehem Steel bought the site for $29,000, and it became part of the U.S. Navy for artillery production. The Connectiv power plant now occupies the land.

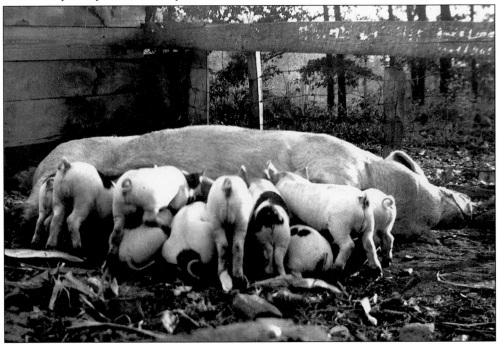

It is mealtime at the Wohlbach farm. This photograph was taken by Stanley Wohlbach during the late 1940s. Wolbach was later responsible for raising the piglets.

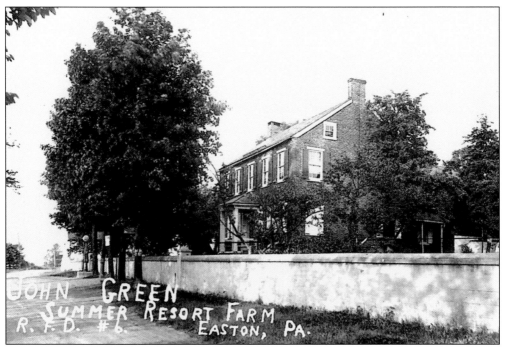

Members of the Pichel family grew tomatoes (below) for the Contadina and Campbell Soup Companies. They also grew produce for the Philadelphia, Newark, and New York markets. The Pichels were members of the Ten Ton Club, which was comprised of an outstanding group of growers. The Pichel farm (above) is located in Lower Saucon Township on what was previously known as Rural Route 1 Hellertown. It consists of 250 acres, plus an 300 additional acres leased to others for farming. The farm remains in the Pichel family today.

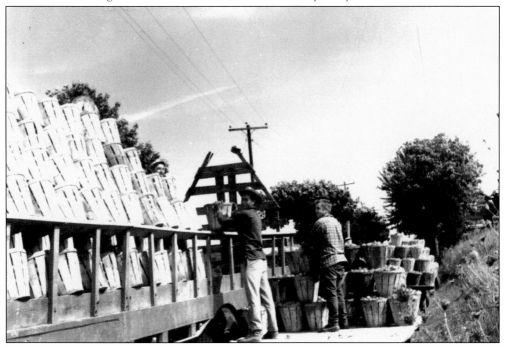

93

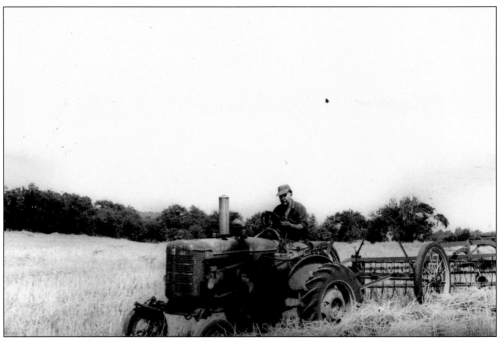

The 1940s-era Farmall tractors were the workhorses of the township. Local farmers like the Pichels (above) depended on their tractor to husk corn and rake hay. Their use made work on a large farm much easier, though farmers still worked from dawn until dusk.

I invite you to attend my Annual PUBLIC SALE of

LIVE STOCK

at my residence, known as the LERCH FARM,

½ **Mile South of Redington Station**
(Lehigh Valley R. R.) near the road leading from Easton and Glendon (up Illick's Hill) to Redington, and on the road leading from Redington to Lutz's Schoolhouse, in Lower Saucon Township, Northampton County, Pa., on

THURSDAY, MARCH 20, 1930
beginning at 1:30 o'clock P. M., the following:

100 PIGS

SHOATS AND SOWS.
Pigs and Shoats weigh from 40 to 100 lbs. each.
Also Brood Sows with litters by time of sale.
One 6 months old Boar.
This is all good home-raised stock. Will be sold first.

 6 Cows and 1 Heifer.
Some of the Cows will have calves by the time of sale. Look them over before sale starts.

 4 HORSES. 1 pair of Sorrel HORSES weighing about 1400 pounds each.
One pair of Bays 4 and 5 years old.

Also a 1-Ton Ford Truck.

Come early as Pigs will be sold first.

Terms, 6 months credit or 3% off for cash.

H. F. Myers, Auctioneer.
J. P. Kunsman, Clerk. **WM. F. HELMS**

Post Office Address: R. D. No. 1, Hellertown, Pa.

This livestock sale was held by William F. Helms at his residence, known as the Lerch farm. In 1930, a buyer had to get up early to purchase a pig. H. F. Myers was auctioneer, and J. P. Kunsman acted as clerk. The final Helms auction was held in the summer of 2004, after Glenn Helms died, as he was the last of the Helms family in Lower Saucon Township. The home, barns, outbuildings, and their contents were put to public sale as well as the land.

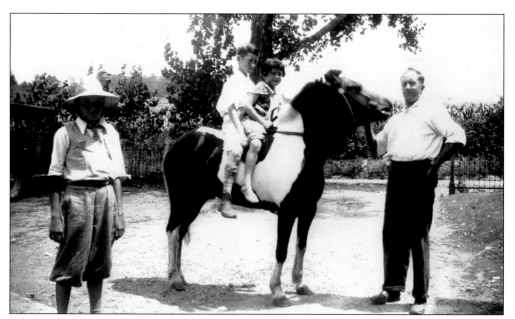

Ethel and William Helms treat their children Glenn and Doris to a pony ride in the early 1930s. Doris became a teacher at both Hellertown and Liberty High Schools, while her brother Glenn taught industrial arts at Broughal Junior High in South Bethlehem. Ethel became an expert on local history in Williams and Lower Saucon Townships.

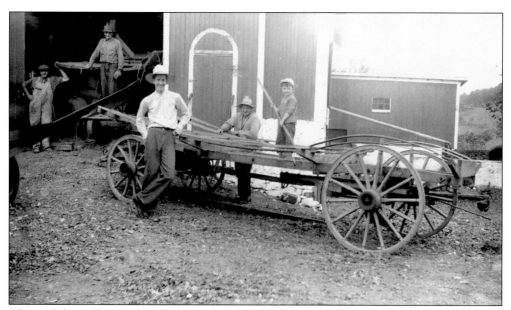

Glenn Helms takes a break from farming with his father (center) and his brother William (holding the pitchfork). Glenn lived on the homestead until his death in 2004.

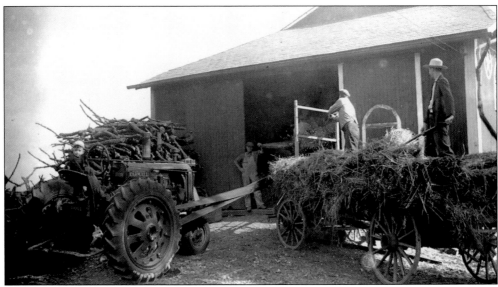

Glenn Helms of Lower Saucon Road pitches hay while his younger brother William sits on a tractor borrowed from neighbor Ramon Pichel.

PIG & SHOAT SALE

The undersigned will offer at Public Sale on his farm, formerly known as the LERCH FARM, about one-half mile

SOUTH OF REDINGTON STATION

(Lehigh Valley R. R.), along the road leading from Easton to Redington, also near the road leading from Easton through Glendon to Hellertown, near Lutz's Schoolhouse, in Lower Saucon Township, Northampton Co., Pa., on

THURSDAY, MAR. 30

1933, beginning at 1:30 o'clock P. M.

125 PIGS AND SHOATS

weighing from 40 to 100 pounds each.

Also a few BROOD SOWS with Litters.

These are all home-raised stock. If in need of a pig or pigs come early.

Terms: 6 months credit or 3% off for cash. (P.O. Address: R. D. 1, Hellertown, Pa.)

H. F. MYERS, Auctioneer.
J. P. KUNSMAN, Clerk.

WM. F. HELMS

In 1933, a pig and shoat sale was a common occurrence at the Helms farm. Auctioneer H. F. Meyers offered 125 pigs on behalf of William Helms. The farm was located on the eastern part of the township, on Lower Saucon Road. In 2004, the farm itself was sold at public auction.

Five

EDUCATION

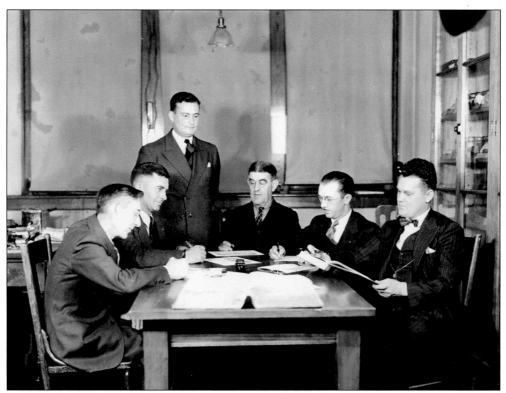

This photograph of the Lower Saucon Township School Board was taken in the late 1930s or early 1940s. From left to right are George Lagalater, Leon Barndt, Robert Sheetz (supervising principal), Edward Hess, Lester Fluck, and Anthony Gawell.

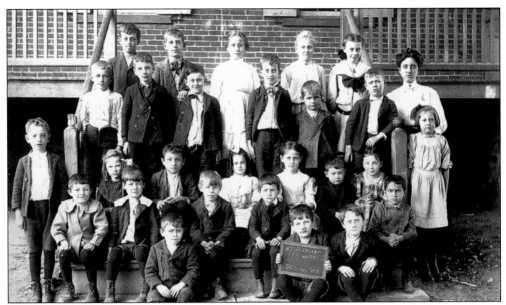

The 1907 class of the Mount Pleasant School in Shimersville poses for a photograph. This school served first through fourth grades. Shimersville, the oldest village in Lower Saucon Township, was named after Jacob Shimer, one of the founders.

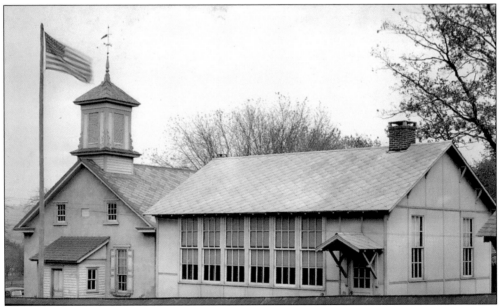

The Lower Saucon Church School was built c. 1882 opposite the Lower Saucon Church on Easton Road. In 1881, the church leased a parcel of its land to the Lower Saucon Township School District with the purpose of erecting a school. It was noted in the lease that the members of Lower Saucon Church still retained the right to pass through the lot. When the school was closed in 1958, it reverted to the property of Lower Saucon Church. The temporary building in the foreground was sold to Charles Byerly, who moved it to the Poconos.

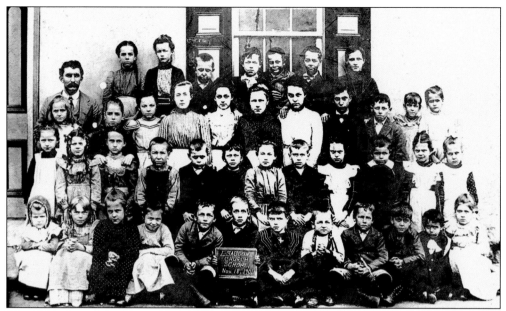

The 1901 class of the Lower Saucon Church School is seen here. Next to the schoolhouse was a large grove available as a playground. As in all the other one-room schoolhouses in Lower Saucon Township, these students were taught in German and English. They learned reading, arithmetic, geography, grammar, spelling, Spenserian writing, and singing. The schoolhouse was closed in 1958.

This lovely work was created by a student in 1845. In Lower Saucon Township, immigrants brought the art form of *fraktur* from Germany. The teachers taught this style to their students through the *vorschriften* method. The teacher made a *fraktur* model, then the students copied the elaborate and colorful letters.

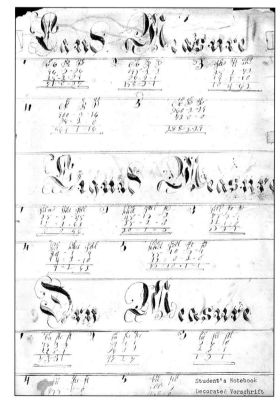

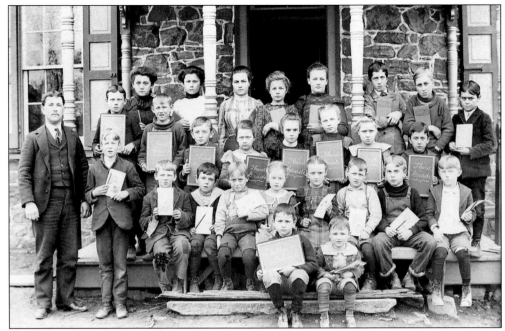

On a deed dated January 25, 1783, Benedict and Anna Mariah Lutz granted about an acre of land for the use of a school. A log building was erected on this property in the 1700s and served as a home, meeting place, and schoolhouse. A second schoolhouse may have been built in 1764. It is believed that it was a polygonal-sided building of stone and roughcast. When this school was torn down in 1880, its stones were used to build the Lutz-Franklin Schoolhouse that exists today. This class portrait, taken in the early 1900s, shows the students in their best clothes.

Starting in the late 1800s, one-room schoolhouse teachers gave these souvenir books to their students at the end of the year. The small souvenir booklet shown here measures six by three and three-quarters inches. It was a gift from teacher Charles F. Behler to his 36 students at the Franklin School No. 2 (Lutz-Franklin School) for the 1902–1903 school year.

On July 17, 1979, the Lutz-Franklin School Museum opened to the public. It closed in 1983. In 1969, Robert R. Hoppes wrote, "Let the old school house stand, to mark a period in the past season, / When education stood for good common sense and sound reason, / When God, Loyalty, Democracy, Patriotism and the Truth, / Were accepted and kept for their true worth by our then growing youth."

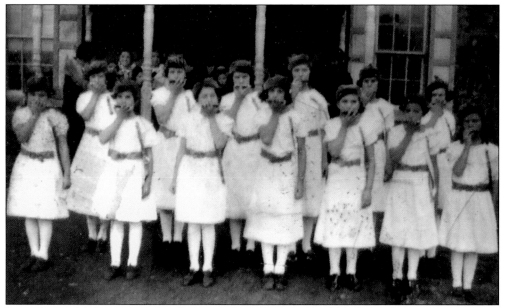

Jerry Angstadt's harmonica band practiced at the Lutz-Franklin Schoolhouse. Pictured are, from left to right, the following: (first row) Ethel Roth, Gloria Borocky, Doris Helms, Crystal Chuck, Ethel Chuck, Ella Ringhoffer, and June Martin; (second row) Francis Chuck, Margaret Ringhoffer, Catherine Chuck, Rose Kish, Mildred Ceban, and Margaret Scheier.

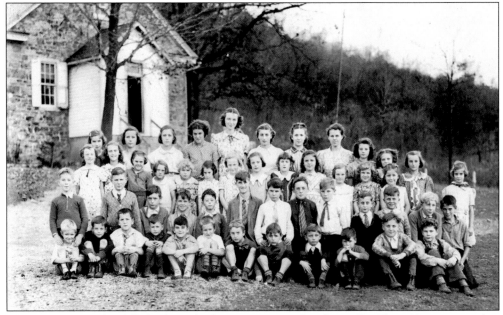

The Wassergass School (below) was built on Wassergass Road in 1879. The 120 square perches of property (slightly more than three-quarters of an acre) for this school were purchased from Jacob and Fayetta Ruch for $75 on July 24, 1879, by the Lower Saucon Township School District. The school was used until 1957, with Barbara Sloyer as the last teacher to serve. Above is a class photograph from the Wassergass School. The teachers and students are unidentified. The building still stands and has been converted into a home.

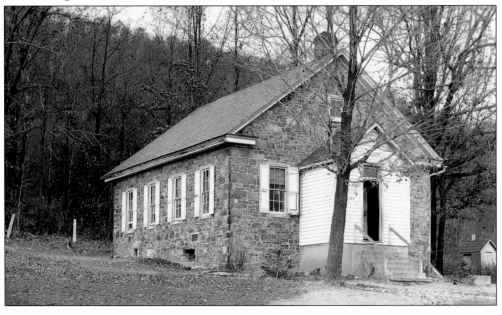

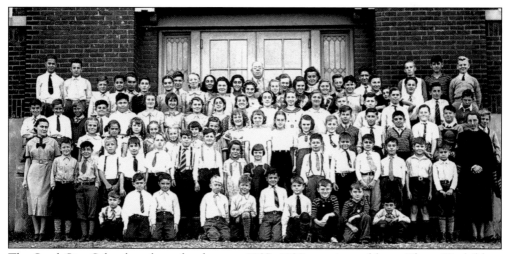

Award of Merit

LEHIGH VALLEY MOTOR CLUB
American Automobile Association

To *Alton Knauss*

this Award of Merit is presented by the *Wassergass School* and Lehigh Valley Motor Club in recognition of meritorious service rendered in protecting the lives of school children while serving as a member of the School Safety Patrol. Each attached seal represents an additional semester of approved service.

Given under our hand at *school*, this *9th* day of *June* 1943

J. W. Rupp
President, Lehigh Valley Motor Club

Patrol Sponsor

Robert E. Scheetz
School Principal

Anna Dickinson
Chief of Police *Teacher*

On June 9, 1943, Alton Knauss received this award for his good work as a safety patrolman. A safety patrol person helps students cross streets when going to and from school. The AAA School Safety Patrol Program has been in existence since 1926 and is used in schools across the country. Alton was attending the Wassergass School when he received his certificate, which was signed by Lehigh Valley Motor Club president J. A. Rupp, principal Robert E. Scheetz, and teacher Anna Dickinson.

The Steel City School students for the year 1937–1938 are pictured here. These 99 children were taught by three teachers: Miss Day (first, second, and third grades), Miss Laubach (fourth, fifth, and sixth grades), and Mr. Kaufman (seventh and eighth grades).

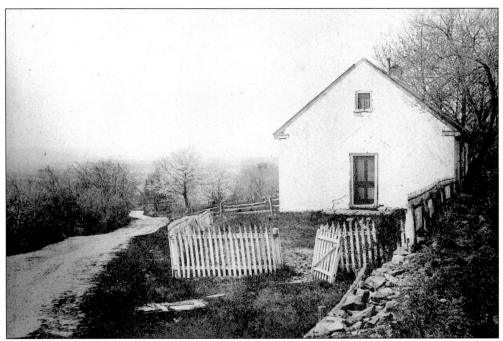

The United School, built in 1879, was located on Wassergass Road, opposite the Lower Saucon Elementary School. The United Church also held services in the building. The school has since been converted to a dwelling.

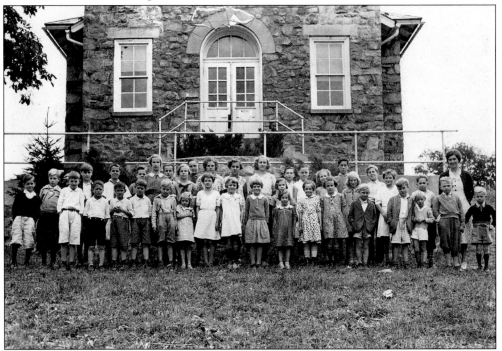

Polk Valley School was the second school located on Polk Valley Road. It was situated a quarter-mile east of the first school and was built on the crest of Kohlberg Hill. The school closed in 1958 and is now a dwelling. Teacher Hilda Knauss is shown in this 1938 class picture.

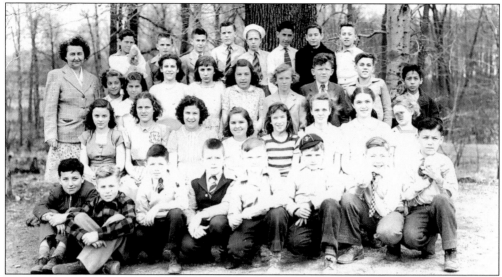

The Southeastern School (below) was located on Hellertown-Ironville Road, a few miles east of Bergstresser's General Store. It was built in 1859 on 80 perches of land sold by the heirs of Charles Stauffer to the Lower Saucon School directors for $19.79. The school closed in 1958, with Henrietta (Mrs. Mark) Grubb as the last teacher. Since 1959, the Southeastern Fire Company has used the building as its headquarters. The above photograph shows the fifth- and sixth-grade class taught by Mae L. Quier in 1946–1947. From left to right are the following: (first row) Franklin Danzer, Louis Fortley, Martin Wallach, LaRue Seigfried, Stanley Sloyer, William Barnett, Eugene Smith, and Joseph Mattos; (second row) Georgene Duga, Shirley Gubish, Jean Yeakel, Nancy Chontofalsky, Robin Fisk, Mary Bright, Barbara Gross, and Joyce Bright; (third row) Miriam Makos, Beatrice Werkheiser, Mercyna Leonard, Elizabeth Loncarie, Joan Madzarac, Roberta Bahrman, Robert Davis, Donald Donnelly, and Ruperto deLeon; (fourth row) Ronald Clauser, John Wukich, George Unguren, LeRoy Sutton, Theodore Lander, Alex Madzarac, Arlington Frack, and Peter Wingert.

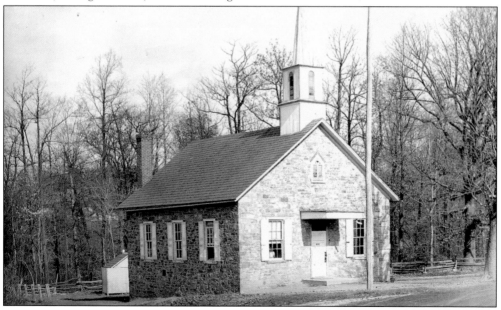

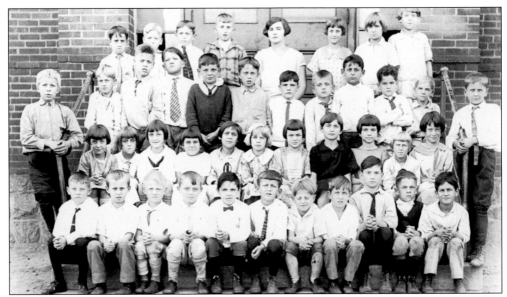

In 1920, the Franklin School was purchased by the Hellertown School District from the Lower Saucon Township School District, when Hellertown annexed the Cross Roads area. The 1927 third-grade students pose with their teacher, Elsie Shaffer Gilmore. From left to right are the following: (first row) Howard Heckman, Joseph Pusch, David Weidner, Leonard Schlener, Ralph Ganssle, Joseph Maloski, Carl Allio, John Rampack, Carl Becker, Zolton Szabo, and George Soldo; (second row) George Wargo, Catherine Frickert, Carolyn Fulmer, Vernetta Dimmick, Mabel Hackett, Mary Szivos, Mary Wargo, Beatrice Weisel, ? Vincovitch, Mary Munson, Hilda Bergstresser, Eleanor Seifert, and John Kajmo; (third row) Walter Amey, Robert Markley, Alfred Belicki, Walter Kresge, John Karp, Leroy Johnson, Elmer Allman, Stephen Repko, Ralph Pearson, and Nevin Schoenenberger; (fourth row) Henry Scheetz, Leroy Bonser, William Danko, Paul Wargo, Mrs. Gilmore, Mildred Scheetz, Mary Horwath, and Grace Duh.

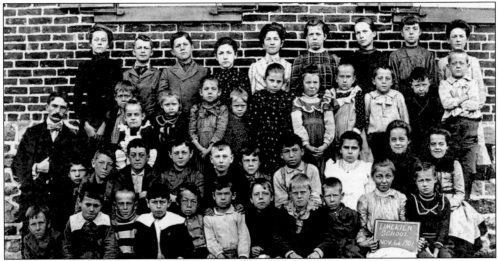

This photograph shows the 41 students who attended the Lime Kiln School in 1901. Their amazing teacher provided education in a one-room schoolhouse for a large number of children in varying grades.

The Leithsville School, also known as the Solliday School, was located on Route 412 in Leithsville. Samuel Solliday and his wife sold a plot of land, 5,750 square feet, for the purpose of a school in 1866. The price was $100. In this photograph, the school on the left was constructed first; the one on the right was erected in the early 1900s to accommodate a growing population. Both structures were converted to private residences after 1958.

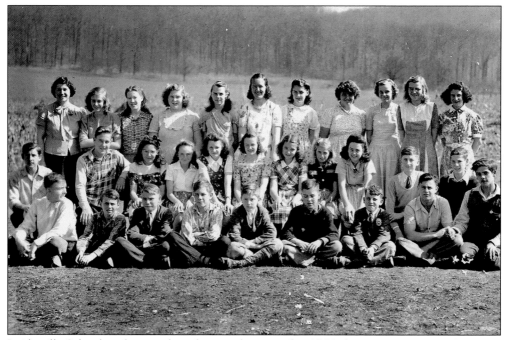

Leithsville School students and teacher are shown in this 1946 class picture.

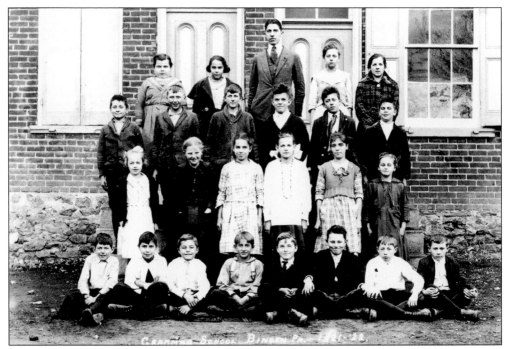

The Bingen School class of 1921–1922 appears here, along with Charles M. Wimmer, who taught these 24 students the required curriculum for grades five through eight. From left to right are the following: (first row) Winfield Hafler, Frank Schriffert, Ed Gangeware, Joe Mohr, Bill Dornblaser, Frank Neibauer, Milton Eisenhart, and Ivan Strauss; (second row) Ida Eisenhart, Betty Becker, Cathryn Shelly, Julia Mohr, Lelia Weaver, and Edna Strauss; (third row) Fred Rieger, Bill Gruver, Alton Diehl, Irwin Shelly, Bill Mohr, and John Schriffert; (fourth row) Lavilla Eisenhart, Edna Brodhead, Mr. Wimmer, Adella Stout, and Alice Schleppy.

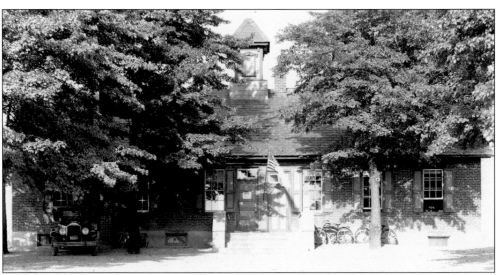

The Bingen two-room schoolhouse was in session from 1875 to 1958. The North Penn Iron Company sold these 40.5 square perches to the Lower Saucon Township School Board for $125 in 1875. The last two teachers to serve the school were Anna Dickinson and Mary Mitchell.

Bob Ravier (left) and Raymond Kelchner are dressed and ready for the 1941 Bingen School Halloween Parade. They are standing in front of the Barris home, which is adjacent to Weiss' Store on Reading Road in Bingen. The Gangewer and Mease families were previous owners of the home.

The Lime Kiln School was built upon the site of a Mennonite meeting house in 1870. It was located on Creek Road in what was a part of Lower Saucon Township until 1920, when the city of Bethlehem annexed the area. The schoolhouse was situated next to a cemetery where Lower Saucon Township's founding families are buried (Heller, Kauffman, Rothrock, and Geissinger). The graves of a few Native Americans can be found there as well. The Lime Kiln School was closed in the late 1950s, when one-room schoolhouses were replaced by large school buildings.

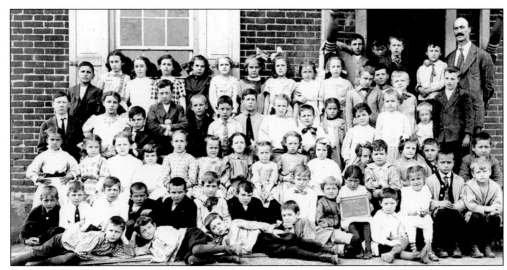

The 1911 class of the Furnace Hill School appears here with teacher Elmer Shiffer. The school was built on the corner of Main and Thomas Streets in the vicinity of the Thomas Iron Company. The school, serving a large Irish immigrant population who worked at the foundry, was therefore also known as the Irish School. In 1919, Hellertown borough annexed this area and purchased the building from the Lower Saucon Township School District. With the increase in population due to the annex, Hellertown borough erected a temporary two-room structure behind this school. The Furnace School was razed c. 1930.

	PRIMARY OR GRAMMAR SCHOOL.	Sept.	Oct.	Nov.	Dec.	Jan.	Feb.	Mar.	April	May	June	Y'rly Av.
EXAMINATIONS. When no examination has been held, the average of the recitations is given.	Reading	vg	vg	vg	vg	vg	vg	vg	vg	exc		
	Spelling	g	g	vg	g	vg	g	g	vg	vg		
	Writing	vg	vg	vg	vg	vg	vg	vg	vg	vg		
	Arithmetic . .	vg	vg	vg		g	g	g	vg	vg		
	Geography . .											
	Grammar . . .											
	Language . . .	g	g	g	g	g	vg	g	g	g		
	Physiology . .											
	U. S. History .											
	Civil Gov't . .											
	Music											
	Drawing . . .	g	g	g	g	vg	vg	vg	g	vg		
	Neatness	vg	vg	vg	g	vg	vg	vg	vg	vg		
ATTENDANCE.	Half Days Present .	40	39	36	40	38	33	38	33	27		
	Excused Absences .											
	Unexcused Absences											
	Times Tardy											
	Times Truant											
SUMMARY. Per Cent. or Character of	Attendance . . .	vg	g	g	vg	g	g	g	g	g		
	Punctuality . . .	vg	vg	vg	vg	vg	vg	vg	vg	vg		
	Recitation	g	g	g	g	g	g	g	g	g		
	Deportment . . .	vg	g	vg	g	vg	vg	g	vg	vg		
	Application . . .	vg	g	vg	vg	vg	g	vg	vg			
	Examination . .											
	Average											
	Rank in Class . . .											
	exc., means excellent.		v. g., very good.		g., good.		m., medium.		p., poor.			

Elizabeth Kies's 1903 report card was graded by her teacher Mary Riegel. The reverse has been signed each month by Elizabeth's father, Frank H. Kies. The family resided on Jefferson Street, which was in Lower Saucon Township at the time. Elizabeth was a fine student, as she received grades of either very good or good in all subjects. The category of "deportment" applied to manners.

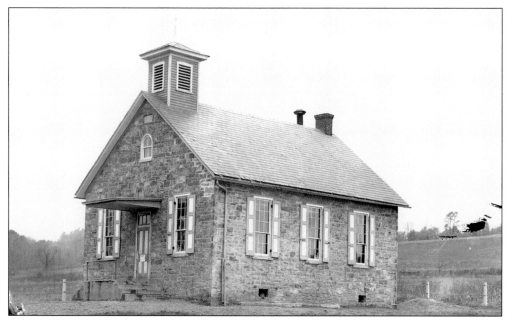

On March 5, 1887, Edward and Catherine Knauss sold 80 square perches of land to the Lower Saucon Township School District for $300. The Union School was built on this property, located in the vicinity of Kunsman's Corner on Hellertown-Raubsville Road. The school was closed in 1958 and converted to a private residence.

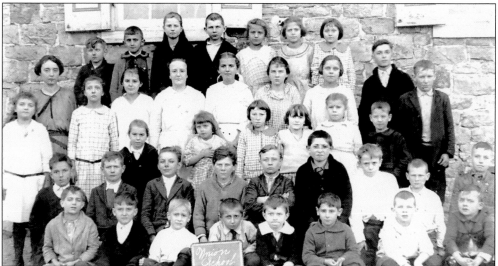

The 1922 Union School class taught by Grace Kunsman Oplinger includes, from left to right, the following: (first row) Clarence Lerch, unidentified, Ralph Laubach, Andrew Oravec, unidentified, Edwin Lerch, Laubach, and unidentified; (second row) unidentified, Austin Laubach, Andrew Chromchak, Theodore Laubach, unidentified, Charles Gerstenberg, Woodrow Gerstenberg, ? Laubach, and Stephen Kokosky; (third row) two unidentified, Sophie Sopko, two unidentified, Joseph Kokosky, and John Sopko; (fourth row) unidentified, Mary Oravec, Mary Kantor, Anna Kunsman, Mae Kunsman, Lucinda Lachbach, Joseph Kantor, and Frank Kantor; (fifth row) Mrs. Oplinger, Joseph Chromchak, Clarence Bauder, Cora Gerstenberg, William Laubach, unidentified, Mary Kokosky, and Laura Sopko.

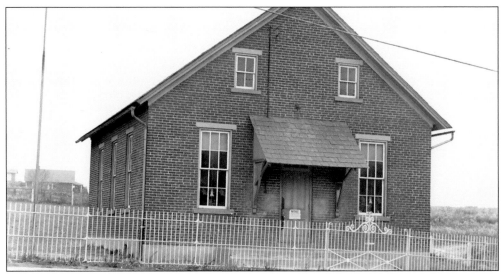

On September 2, 1890, Maria Ott granted 80 perches of land to the Lower Saucon Township School Board for $450. The lot was located on old Route 12. The Lehigh Mountain School continued to serve residents until 1957.

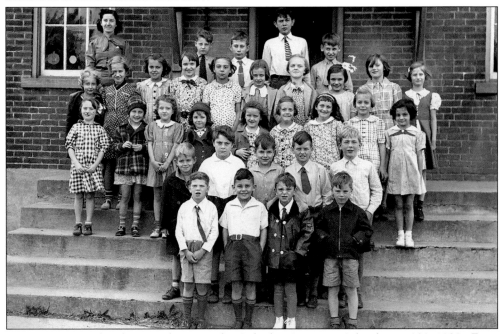

Miss Levine taught these students at the Lehigh Mountain School in 1938–1939. From left to right are the following: (first row) Lagerne Keck, Norman ?, Buddy Hafner, and ? Nonnenmacher; (second row) David Clauser, William Rothrock, Robert Stine, Fred Kohler, and Robert Martin; (third row) Emma Rothrock, unidentified, Joyce Koehler, Dolores Lipko, two unidentified, Joyce Kline, Catherine Mindler, and Rosemary Pum; (fourth row) unidentified, Jean Froch, Gertrude Schmidt, Sylvia Koshko, Lorraine Hafner, Janet Clauser, Doris Green, Joyce Stefan, Anne Rothrock, and June Buss; (fifth row) William Finkbeiner, Elmer Trapp, William Pum, and Donald Froch. The Lehigh Mountain School stood on the crest of the hill on Route 378, just short of the Fountain Hill borough line. It has since been razed.

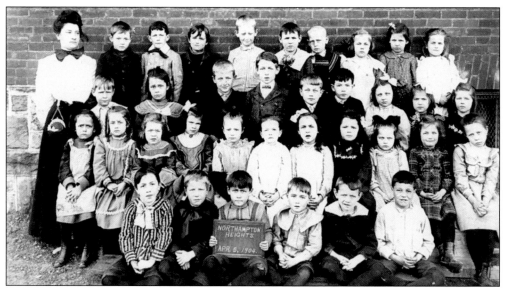

This 1904 class portrait shows students attending Northampton Heights School, built in 1901 by the architect Alden W. Leh, who designed many buildings in the Lehigh Valley (the Bethlehem Steel Company office building, the residence and store of William Boehm). The citizens of Northampton Heights voted to separate from Lower Saucon Township and merge with Bethlehem in 1920. They felt they would receive better services for their taxes from the city of Bethlehem.

A good example of the *vorschriften* method of teaching writing is pictured above. Note that Silas A. Wasser's teacher at the United School, Milton Hess, has written a sentence at the top of the page. Silas has attempted to copy the correct formation of the letters by writing the sentence several times. A teacher would typically choose a proverb as a model. This page was taken from Silas's penmanship workbook for the year 1865–1866.

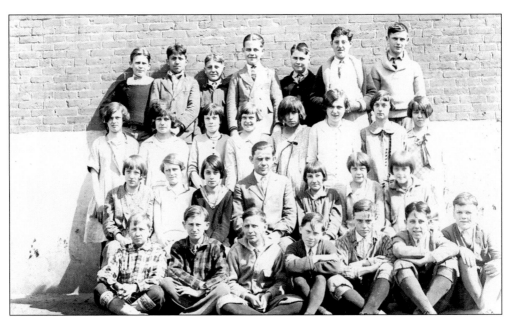

Mr. Shock taught this class at the Seidersville School in 1926.

On August 13, 1892, Dorothea Laible and her brother Edeam, along with John and Emma Kauffman, sold 80 perches of land on Old Philadelphia Pike to the Lower Saucon Township School District for $500. The property measured 100 by 218 feet. A two-room schoolhouse was constructed in 1892. In the early 1920s, an addition of two rooms and a connecting room was built. The school operated until 1958, with the opening of the Lower Saucon Elementary School. The last educators to use the building were superintendent G. Raymond Todd, William Szabo, Myrtle Roth, Charlotte Baugh, and Henrietta Long. The building was used as the Lower Saucon Township Town Hall until the new town hall opened in 2002. The township still owns the building and has leased it to the Saucon Valley Community Center.

Shown here is a page from 16-year-old Harvey Flexer's school workbook for the 1885–1856 year. He attended the Seidersville School.

How I spent Christmas.

I awoke about at six o'clock I first thought at the night before, when I was acting Santa Claus. first I did was to get out of bed and dress myself, and then do my morning's work. I recieved a pair of stockings, a box collars, candy, and an orange I did'nt hardly give any presents, but I gave Charles Snyder a kick for his Christmas present.

In the forenoon I was at home, took dinner at home, and in the Afternoon and Evening I was to the festival. I do not know any things that occurred on the day around her This anniversary is celebrated because, Jesus Crist our Lord, was born on that day. The day is celebrated in a Christian Like manner

Harvey A. Flexer.
Seidersville
Northampton Co.,
Dec 29, 1885. Pa.

COMMON SCHOOLS OF PENNSYLVANIA

ACT OF MAY 8th 1854.

No.

Teachers' Professional Certificate

It is hereby certified that *Lillie Muschlitz* is a person of good moral character, and has passed a *Thorough Examination* in Orthography, Reading, Writing, Arithmetic, Geography, English Grammar, History of the United States, Physiology and Hygiene.

and in the **Theory of Teaching**.

May 11, 1901.

H. R. Bender Superintendent.

Northampton County Penn[a]

To receive this teaching certificate for the Common Schools of Pennsylvania, Lillie Muschlitz needed to complete a two-year study at a Pennsylvania Normal School and pass an exam. She accomplished both tasks and was granted this certificate on May 11, 1901, by H. R. Bender, superintendent of Northampton Common Schools.

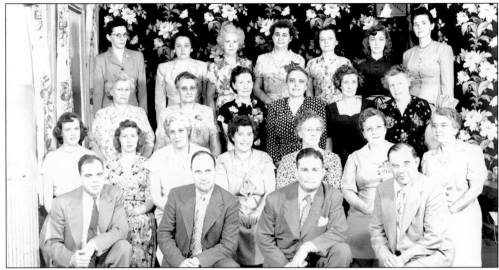

This photograph, taken on June 9, 1950, at a faculty dinner, reveals those who taught in the Lower Saucon Township one-room schoolhouses. From left to right are the following: (first row) Thomas Weston, G. Raymond Todd, Robert Scheetz, and William Schoch; (second row) Carol Williams, Margaret Fluck, Ann Johnson, Hilda Knauss, Anna Dickinson, Marie Legat, and Margaret Miller; (third row) Myrtle Roth, Elsie Gilmore, Mary Mitchell, Allah Richter, Dorothy Uberoth, and Ruth Heater; (fourth row) Hennrietta Long, Kathryn Kost, Marie Nagy, Mae Quier, Marie Rhoads, Rosemary Focht, and Minnie Sheetz.

The Lower Saucon Elementary School was built in 1958 on Wassergass Road for a sum of $940,000. It was a state-of-the-art building with 22 classrooms, a cafeteria, auditorium, health suite, and library. The building was closed in 1999, when the Saucon Valley School District opened a new elementary school on the same campus as the high school. This building was then sold to a private owner. The faculty pictured here includes, from left to right, the following: (first row) Edith Boyer, Gladys Ackerman, Clara Campbell, William Szabo, Mrs. Praetor, Ellen Nixon, and Pat McGonigle; (second row) Charlotte Baugh, Ruth Uberoth, Allah Richter, Ruth Heater, Sadie Harhay, Phyllis Stephens, Elsie Boehm, Marie Nagy, Margaret Miller, and Mae Quier; (third row) Henrietta Grubb, Anna Dickinson, Barbara Sloyer, Lou Mazzo, Richard Kantor, Robert Thompson, Renee Kerner, Stanley Sloyer, and Henrietta Long.

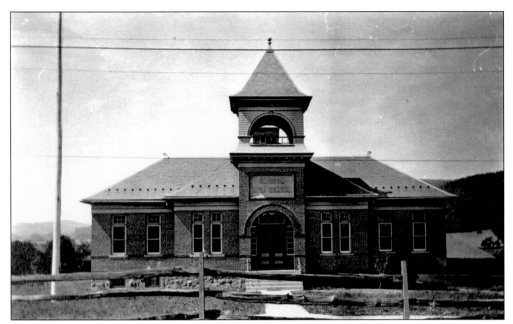

The Saucon High School was located at the corner of Kichline Avenue and Hellertown Road in the Wagner Terrace area. The Zawick Manufacturing Company took possession of the building when the Lower Saucon Township School District closed the school.

Pictured here is another building, constructed in 1910 as the Saucon High School. The Hellertown School District purchased the building from the Lower Saucon Township School District in 1920, and it became Hellertown High School. The building then became the Wolf Elementary School in 1931. Douglas Koch was the last principal to serve. In 1982, the Hellertown School District sold the school to a private owner who converted it into apartments.

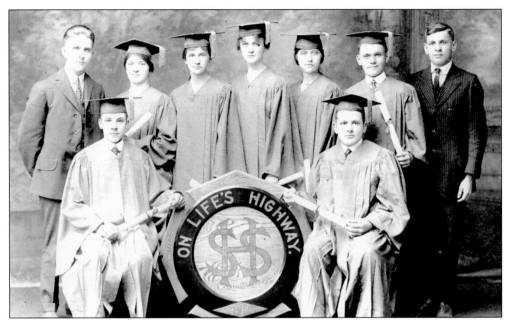

The Saucon High School graduating class of 1918 is pictured here. On the left is principal Stanley Landis, and on the far right is Robert R. Hoppes. Hoppes was not only a stellar educator but an instrumental force in preserving the Lutz-Franklin Schoolhouse and organizing the Lower Saucon Township Historical Society. From 1912 to 1959, he held positions in the Lower Saucon and Hellertown School Districts as a teacher and principal. He even taught fifth grade in 1915 at the Lutz-Franklin Schoolhouse. Hoppes created the first basketball team at the high school, coached soccer, directed drama, and served as librarian.

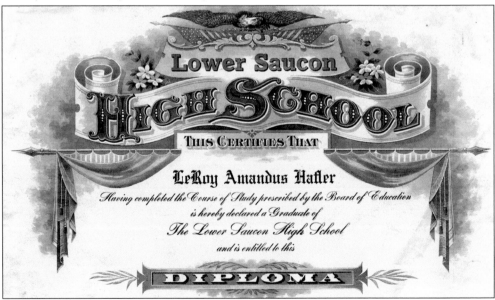

In 1918, it was a great achievement to graduate from high school, especially in the Lower Saucon Township farming community. Children, needed for work on their family farms, had usually left school by eighth grade. This diploma belongs to LeRoy Amandus Hafler, who graduated from the Lower Saucon High School on May 28, 1918.

Six

LANDMARKS

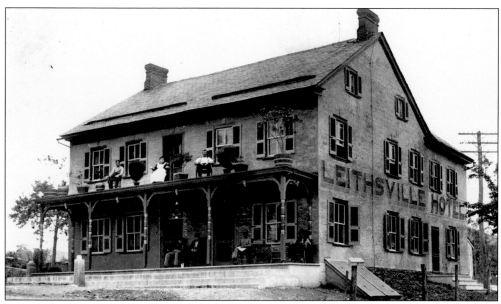

The Leithsville Hotel was built in 1908 next to a graveyard. The town of Leithsville, founded in the southwestern area of the township, acquired its name from the Leiths or Leyds family, who lived in the vicinity. Peter Leyd was the first settler and ancestor. According to local myth, guests of the inn may encounter the ghost of a man who was lynched for an unknown crime in the 18th century. The ghost has been seen in the lobby and in the barn where he was hanged. Another myth concerning the inn tells of a traveling salesman who was murdered in his room. There is a spot of blood that continues to reappear despite cleaning and painting. Owners of the inn deny the veracity of either story.

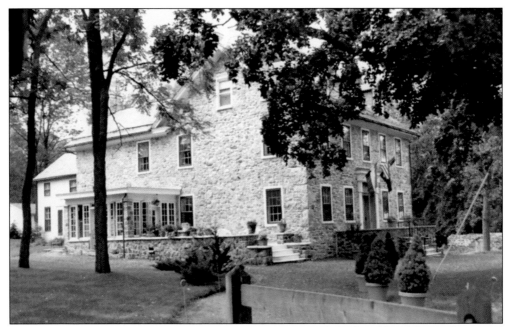

Wydnor Hall on Old Philadelphia Pike is Lower Saucon's only bed-and-breakfast and is owned by innkeepers Charles and Kristina Taylor. Built in 1807 as a private residence, the stone home was known as the Bordaria Plantation. The original land warrant dates back to April 22, 1746, granting 98 acres to Christian Berger. The home has gone through many changes and has recently been restored by the Taylors. Some previous owners were David Reigel, David Weidner, Philip Bahl, Erhard Rau, Daniel Heller, and Conrad Rau.

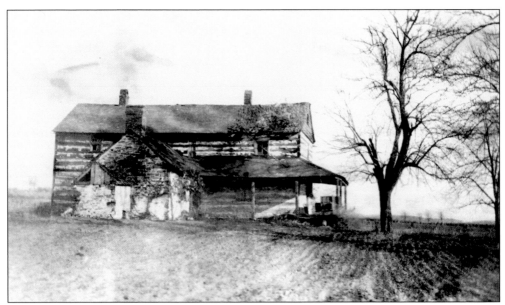

Built in 1748, the original Christoph Heller homestead was located in Seidersville on the site currently occupied by a movie theater and supermarket on Route 378. This photograph dates from 1913.

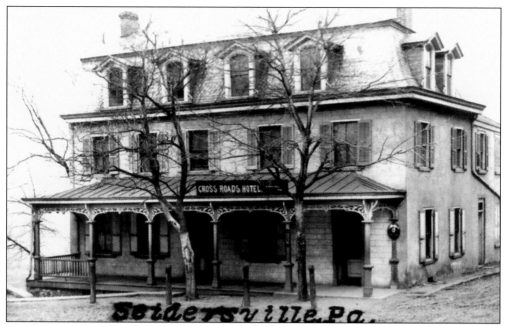

The Cross Roads Hotel was located on Old Philadelphia Pike in Seidersville. In this photograph taken from a postcard marked 1916, the signboard states O. Bryfogl as proprietor. It is possible that Charles Cooper was the original innkeeper during the mid-1800s. In the 1930s, Ann Little was the owner.

The beginnings of the Saucon Valley Country Club were established in 1920, when a group of business leaders purchased 205 acres. The properties were previously four farms from the families Grim, Albright, Bahl, and Gangewer. These farms represented successful enterprises in the 1800s. The Bahl-Gangewer Mine was one of the largest iron ore mines in Lower Saucon Township. A lime kiln, brick furnace, and gristmill were also operated on these properties. Pictured here in 1934 is the clubhouse of the Saucon Valley Country Club.

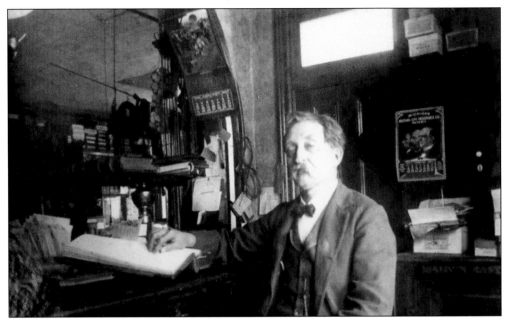

Jacob Campbell became the proprietor of the main general store in Bingen after the Civil War. A veteran of that conflict, he was severely wounded at Gettysburg. Campbell took over the business from William Yeager, an abolitionist, who had started the business during the 1860s. Campbell's business eventually passed to Preston Weiss. This photograph was taken in the early 1900s.

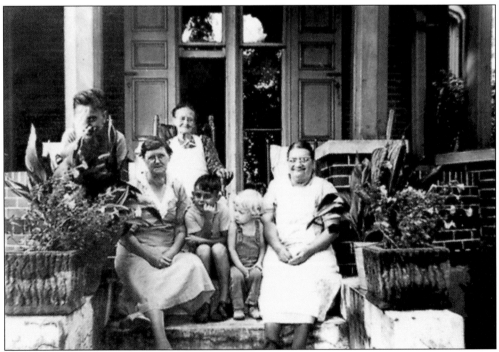

Folks gather socially on a sunny day on the back porch of Weiss' Store in the early 1950s. Lizzie Frey sits to the right. On the rocking chair is Matilda Weiss. Also seen are Amelia Mease (left) and her grandchildren.

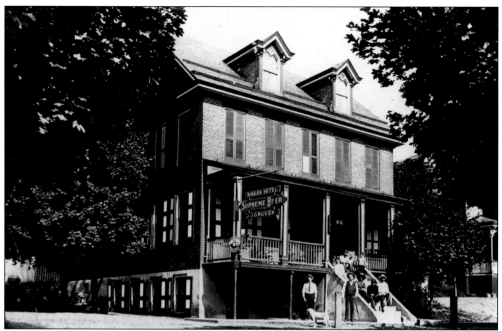

Gruver's Hotel (above) has stood next to the William R. Yeager estate in Bingen for many years and continues to be a stately monument to late-19th and early-20th-century local color. Proprietor John J. Gruver was born on June 19, 1869, and died on December 4, 1952. His wife, Emma Bartsch Gruver, lived between September 19, 1876, and September 26, 1967. The Gruvers operated a baking business in Springtown before acquiring the hotel.

John J. Gruver and his wife, Emma B. Gruver, pictured here, took ownership of Gruver's Hotel in 1905. Ruth Gruver, the current resident of the building, is the couple's daughter. A son, Russell, died at age 21.

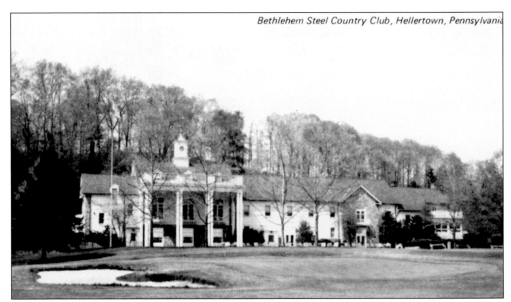

In 1948, the Bethlehem Steel Corporation funded this golf course, called the Bethlehem Steel Country Club (Silver Creek Country Club today), which was built as a recreational facility for plant supervisors. Bethlehem Steel purchased the land for the country club from the Wirth family for $150,000. A nine-hole course was created north of Durham Street in Hellertown. In the early 1960s, the course was expanded to 18 holes on land purchased from the Mar and Wirth families.

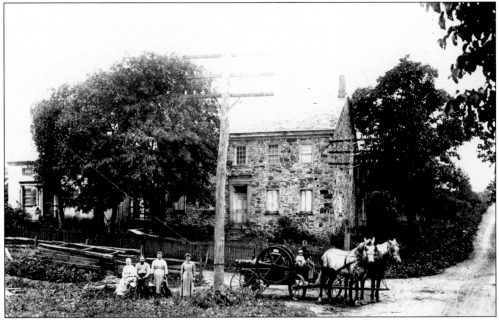

The barn, Widow's House (center), and Michael Heller House (right) were built between 1750 and 1800 on the site that became the family's homestead and sawmill industry. Charles Stever occupied the home from 1863 to 1923 and continued sawmill operations. Today, the Saucon Valley Conservancy manages the Heller and Widow's Houses as a museum with rooms furnished in certain historical periods.

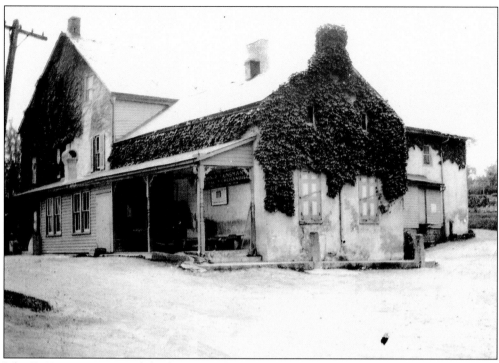

John P. Kunsman managed the former Ruch's Store and Gristmill from 1912 to 1932. Kunsman, born in Lower Saucon Township in 1872, was the son of John J. and Maria Deemer Kunsman. His wife, Laura, was born in 1875, the daughter of Joseph E. and Susanna Barbara Ruch. In 1932, the Kunsmans' son Kenneth assumed operation of the general store and gristmill.

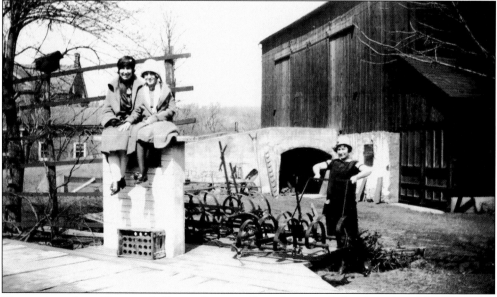

The grain scale at Kunsman's Gristmill was well used, particularly when the mill and general store were in their "hay day."

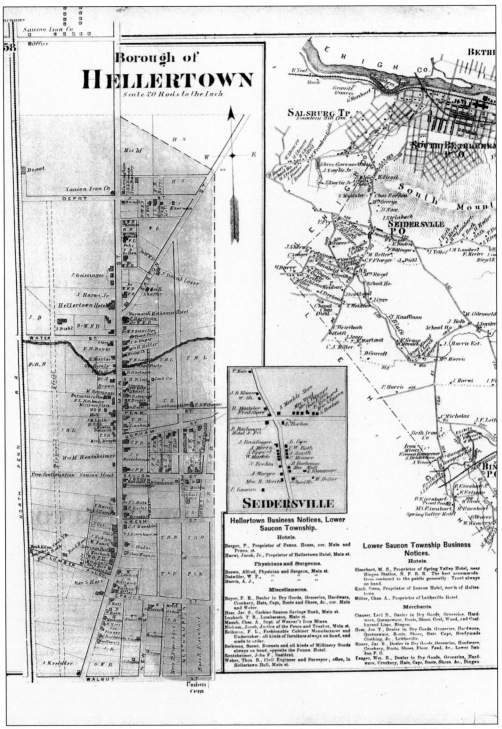

This map of Lower Saucon appeared in the 1874 Beers atlas. Note the borough of Hellertown is not a part of Lower Saucon Township.

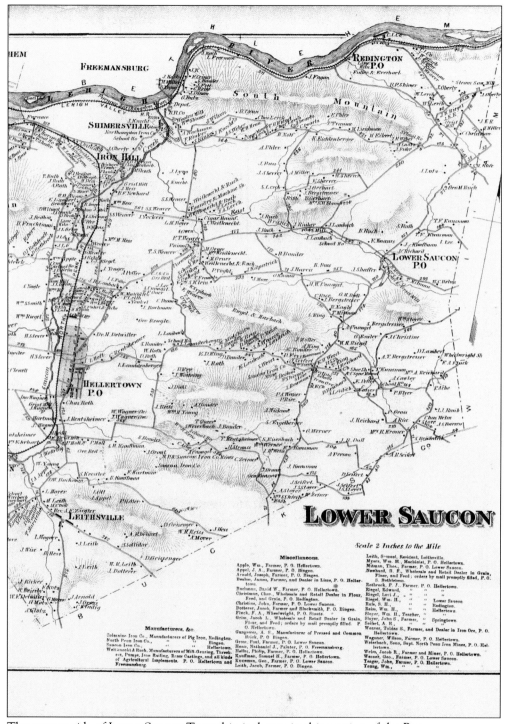

The eastern side of Lower Saucon Township is shown in this portion of the Beers map.

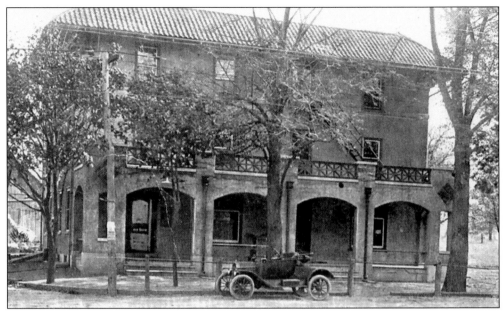

The Cross Roads Hotel was built in the late 1800s on the corner of High and Main Streets in Hellertown. It faced the frequently used High Street. With the growth of Hellertown, the hotel's owners decided it should instead face Main, which had become a busier street. With several mules and long logs in place, the hotel's orientation was turned toward Main Street. The photograph above was taken after this change. The Mateys purchased the hotel from the Griffiths 52 years ago, and it continues as a popular accommodation spot and restaurant.

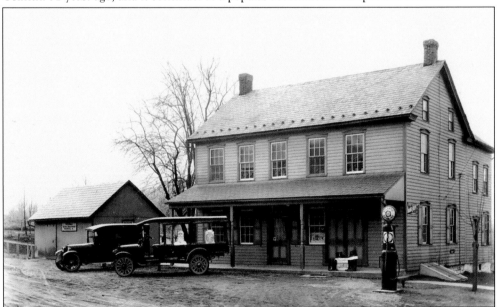

For 100 years, A. L. Bergstresser and Son store has served the surrounding area with everything from food, clothes, and cloth to farm implements. Three generations of Bergstressers ran the general store until 2002. This was a meeting place where for decades the news of the day was discussed and debated, often in Pennsylvania German (also referred to as Pennsylvania Dutch). Today, the store retains much of its originality.